W9-CUQ-621

Prefatory Note

Mr. Murray wishes to point out that this
book is written in English by a native of Japan

The Ideals of
the East

With Special Reference to
the Art of Japan

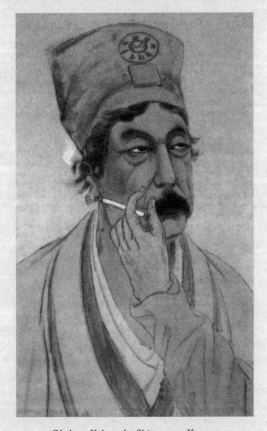

Okakura Kakuzo by Shimomura Kanzan

Courtesy of The University Art Museum,
Tokyo National University of Fine Arts and Music

The Ideals of the East

With Special Reference to the Art of Japan

Kakuzo Okakura

STONE BRIDGE CLASSICS
Stone Bridge Press
Berkeley, California

YOHAN CLASSICS
IBC Publishing
Tokyo, Japan

Originally published in 1904 by E. P. Dutton & Co., New York.

Published simultaneously in the United States by Stone Bridge Press, P.O. Box 8208, Berkeley, California 94707, www.stonebridge.com, and in Japan by IBC Publishing, Akasaka Community Bldg 5F, 1-1-8 Moto-Akasaka, Minato-Ku, Tokyo 107-0051, www.ibcpub.co.jp.

Trade distribution in the United States and Canada by Consortium Book Sales and in Japan by Yohan, Inc.

For information on distribution and purchase worldwide contact Stone Bridge Press at sbp@stonebridge.com, 510-524-8732 (tel), or 510-524-8711 (fax).

Cover and book design by Robert Goodman, Silvercat™ San Diego, California.

© 2007 Stone Bridge Press.

All rights reserved.

No part of this book may be reproduced in any form without permission from the publisher.

Printed in the United States of America.

2012 2011 2010 2009 2008 2007 10 9 8 7 6 5 4 3 2 1

ISBN 978-1-933330-25-9 (USA)
ISBN 978-4-89684-295-1 (JAPAN)

Contents

Introduction • 1

The Range of Ideals • 9

The Primitive Art of Japan • 17

Confucianism—Northern China • 23

Laoism and Taoism—Southern China • 33

Buddhism and Indian Art • 43

The Asuka Period (550–700 A.D.) • 55

TheNara Period (700–800 A.D.) • 69

The Heian Period (800–900 A.D.) • 79

The Fujiwara Period (900–1200 A.D.) • 87

The Kamakura Period (1200–1400 A.D.) • 95

Ashikaga Period (1400–1600 A.D.) • 101

Toyotomi and Early Tokugawa Period
(1600–1700 A.D.) • 113

Later Tokugawa Period • 119

The Meiji Period　•　125

The Vista　•　141

Chronology of Asian Art　•　147

Introduction

Kakuzo Okakura, the author of this work on Japanese Art Ideals—and the future author, as we hope, of a longer and completely illustrated book on the same subject—has been long known to his own people and to others as the foremost living authority on Oriental Archæology and Art.

Although then young, he was made a member of the Imperial Art Commission which was sent out by the Japanese Government in the year 1886, to study the art history and movements of Europe and the United States. Far from being overwhelmed by this experience, Mr. Okakura only found his appreciation of Asiatic art deepened and intensified by his travels, and since that time he has made his influence felt increasingly in the direction of a strong re-nationalising of Japanese art in opposition to that pseudo-Europeanising tendency now so fashionable throughout the East.

On his return from the West, the Government of Japan showed its appreciation of Mr. Okakura's services and convictions by making him Director of their New Art School at Ueno, Tokyo. But political changes brought fresh waves of so-called Europeanism to bear on the school, and in the year 1897 it was insisted that European methods should become increasingly prominent. Mr. Okakura now resigned. Six months later thirty-nine of the strongest young artists

in Japan had grouped themselves about him, and they had opened
the Nippon Bijitsuin, or Hall of Fine Arts, at Yanaka, in the suburbs
of Tokyo, to which reference is made in chapter xiv. of this book.

If we say that Mr. Okakura is in some sense the William
Morris of his country, we may also be permitted to explain
that the Nippon Bijitsuin is a sort of Japanese Merton Abbey.
Here various decorative arts, such as lacquer and metalwork,
bronze casting, and porcelain, are carried on, besides Japanese
painting and sculpture. The members attempt to possess them-
selves of a deep sympathy and understanding of all that is best
in the contemporary art movements of the West, at the same
time that they aim at conserving and extending their national
inspiration. They hold proudly that their work will compare
favourably with any in the world. And their names include those
of Hashimoto Gaho, Kanzan, Taikan, Sessei, Kozn, and oth-
ers equally famous. Besides the work of the Nippon Bijitsuin,
however, Mr. Okakura has found time to aid his Government
in classifying the art treasures of Japan, and to visit and study
the antiquities of China and India. With regard to the latter
country, this is the first instance in modern times of the arrival
of a traveller possessed of exhaustive Oriental culture, and Mr.
Okakura's visit to the Caves of Ajanta marks a distinct era in
Indian archæology. His acquaintance with the art of the same
period in Southern China enabled him to see at once that the
stone figures now remaining in the caves had been intended
originally merely as the bone or foundation of the statues, all the
life and movement of the portrayal having been left to be worked
into a deep layer of plaster with which they were afterwards cov-
ered. A closer inspection of the carvings gives ample justification
of this view, though ignorance, "the unconscious vandalism of
mercenary Europe," has led to an unfortunate amount of "clean-

ing" and unintentional disfigurement, as was the case with our own English parish churches only too recently.

Art can only be developed by nations that are in a state of freedom. It is at once indeed the great means and fruitage of that gladness of liberty which we call the sense of nationality. It is not, therefore, very surprising that India, divorced from spontaneity by a thousand years of oppression, should have lost her place in the world of the joy and the beauty of labour. But it is very reassuring to he told by a competent authority that here also once, as in religion during the era of Asoka, she evidently led the whole East, impressing her thought and taste upon the innumerable Chinese pilgrims who visited her universities and cave-temples, and by their means influencing the development of sculpture, painting, and architecture in China itself, and through China in Japan.

Only those who are already deep in the problems peculiar to Indian archæology, however, will realise the striking value of Mr. Okakura's suggestions regarding the alleged influence of the Greeks on Indian sculpture. Representing, as he does, the great alternative art-lineage of the world—namely, the Chinese—Mr. Okakura is able to show the absurdity of the Hellenic theory. He points out that the actual affinities of the Indian development are largely Chinese, but that the reason of this is probably to be sought in the existence of a common early Asiatic art, which has left its uttermost ripple-marks alike on the shores of Hellas, the extreme west of Ireland, Etruria, Phœnicia, Egypt, India, and China. In such a theory, a fitting truce is called to all degrading disputes about priority, and Greece falls into her proper place, as but a province of that ancient Asia to which scholars have long been looking as the Asgard background of the great Norse sagas. At the same time, a new world is opened to future

scholarship, in which a more synthetic method and outlook may correct many of the errors of the past.

With regard to China, Mr. Okakura's treatment is equally rich in suggestions. His analysis of the Northern and Southern thought has already attracted considerable attention amongst the scholars of that country, and his distinction between Laoism and Taoism stands widely accepted. But it is in its larger aspects that his work is most valuable. For be holds that the great historic spectacle with which the world is necessarily familiar, of Buddhism pouring into China across the passes of the Himalayas, and by the sea-route through the straits—that movement which probably commenced under Asoka and became tangible in China itself at the time of Nâgaruna in the second century A.D.—was no isolated event. Rather was it representative of those conditions under which alone can Asia live and flourish. The thing we call Buddhism cannot in itself have been a defined and formulated creed, with strict boundaries and clearly demarcated heresies, capable of giving birth to a Holy Office of its own. Rather must we regard it as the name given to the vast synthesis known as Hinduism, when received by a foreign consciousness. For Mr. Okakura, in dealing with the subject of Japanese art in the ninth century, makes it abundantly clear that the whole mythology of the East, and not merely the personal doctrine of the Buddha, was the subject of interchange. Not the Buddhaising but the *Indianising* of the Mongolian mind, was the process actually at work—much as if Christianity should receive in some strange land the name of Franciscanism, from its first missioners.

It is well known that in the case of Japan the vital element in her national activity lies always in her art. Here we find, at each period, the indication and memorial of those constituents of her

consciousness which are really essential. It is an art, unlike that of ancient Greece, in which the whole nation participates; even as in India, the whole nation combines to elaborate the thought. The question, therefore, becomes profoundly interesting: what is that thing, as a whole, which expresses itself through Japanese art as a whole? Mr. Okakura answers without hesitation: It is the culture of Continental Asia that converges upon Japan, and finds free living expression in her art. And this Asiatic culture is broadly divisible, as he holds, into Chinese learning and Indian religion. To him, it is not the ornamental and industrial features of his country's art which really form its characteristic elements, but that great life of the ideal by which it is hardly known as yet in Europe. Not a few drawings of plum blossoms, but the mighty conception of the Dragon; not birds and flowers, but the worship of Death; not a trifling realism, however beautiful, but a grand interpretation of the grandest theme within the reach of the human mind,—the longing desire of Buddahood to save others and not itself—these are the true burden of Japanese art. The means and method of this expression Japan has ever owed to China; it is Mr. Okakura's contention, however, that for the ideals themselves she has depended upon India. It is his belief that her great epochs of expression have always followed in the wake of waves of Indian spirituality. Thus, benefit of the stimulating influence of the great southern peninsula, the superb art-instincts of China and Japan must have been lowered in vigour and impoverished in scope, even as those of Northern and Western Europe would undoubtedly have been, if divorced from Italy and the message of the Church. "Bourgeois" our author holds that Asiatic art could never have been, standing in sharp contrast in this respect to that of Germany, Holland, and Norway amongst ourselves. But he would admit, we may

presume, that it might have remained at the level of a great and beautiful scheme of peasant decoration.

Exactly how these waves of Indian spirituality have worked to inspire nations, it has been his object throughout the following pages to show us. First understanding the conditions upon which they had to work, the race of Yamato in Japan, the wonderful ethical genius of Northern China, and the rich imaginativeness of the south, we watch the entrance of the stream of Buddhism, as it proceeds to overflow and unite the whole. We follow it here, as the first touch of the dream of a universal faith gives rise to cosmic conceptions in science, and the Roshana Buddha in art. We watch it again as it boils up into the intense pantheism of the Heian period, the emotionalism of the Fujiwara, the heroic manliness of the Kamakura.

It has been by a recrudescence of Shintoism, the primitive religion of Yamato, largely shorn of Buddhistic elements, that the greatness of the Meiji period seems to have been accomplished. But such greatness may leave inspiration far behind. All lovers of the East stand dismayed at this moment before the disintegration of taste and ideals which is coming about in consequence of competition with the West.

Therefore it is worth while to make some effort to recall Asiatic peoples to the pursuit of those proper ends which have constituted their greatness in the past, and are capable of bringing about its restitution. Therefore is it of supreme value to show Asia, as Mr. Okakura does, not as the congeries of geographical fragments that we imagined, but as a united living organism, each part dependent on all the others, the whole breathing a single complex life.

Aptly enough, within the last ten years, by the genius of a wandering monk—the Swâmi Vivekânanda—who found his way

to America and made his voice heard in the Chicago Parliament
of Religions in 1893, Orthodox Hinduism has again become
aggressive, as in the Asokan period. For six or seven years past,
it has been sending its missionaries into Europe and America,
providing for the future a religious generalisation in which the
intellectual freedom of Protestantism—culminating in natural
science—can be combined with the spiritual and devotional
wealth of Catholicism. It would almost seem as if it were the des-
tiny of imperial peoples to be conquered in turn by the religious
ideas of their subjects. "As the creed of the down-trodden Jew
has held half the earth during eighteen centuries, so," to quote
the great Indian thinker just mentioned, "it seems not unlikely
that that of the despised Hindu may yet dominate the world." In
some such event is the hope of Northern Asia. The process that
took a thousand years at the beginning of our era may now, with
the aid of steam and electricity, repeat itself in a few decades and
the world may again witness the Indianising of the East.

If so, one of many consequences will be that we shall see
in Japanese art a recrudescence of ideals parallel to that of the
Mediæval Revival of the past century in England. What would
be the simultaneous developments in China? in India? For what-
ever influences the Eastern Island Empire must influence the
others. Our author has talked in vain if he has not conclusively
proved that contention with which this little handbook opens,
that Asia, the Great Mother, is for ever One.

NIVEDITA,

OF RAMAKRISHNA-VIVEKÂNANDA

17 BORIC PARA LANE,
BAGH BAZAAR, CALCUTTA

The Range of Ideals

Asia is one. The Himalayas divide, only to accentuate, two mighty civilisations, the Chinese with its communism of Confucius, and the Indian with its individualism of the Vedas. But not even the snowy barriers can interrupt for one moment that broad expanse of love for the Ultimate and Universal, which is the common thought-inheritance of every Asiatic race, enabling them to produce all the great religions of the world, and distinguishing them from those maritime peoples of the Mediterranean and the Baltic, who love to dwell on the Particular, and to search out the means, not the end, of life.

Down to the days of the Mohammedan conquest went, by the ancient highways of the sea, the intrepid mariners of the Bengal coast, founding their colonies in Ceylon, Java, and Sumatra, leaving Aryan blood to mingle with that of the sea-board races of Burmah and Siam, and binding Cathay and India fast in mutual intercourse.

The long systolic centuries—in which India, crippled in her power to give, shrank back upon herself, and China, self-absorbed in recovery from the shock of Mongol tyranny, lost her intellectual hospitality—succeeded the epoch of Mahmoud of Ghazni, in the eleventh century. But the old energy of communication lived yet

in the great moving sea of the Tartar hordes, whose waves recoiled from the long walls of the North, to break upon and overrun the Punjab. The Hunas, the Sakas, and the Gettaes, grim ancestors of the Rajputs, had been the forerunners of that great Mongol outburst which, under Genghis Khan and Tamerlane, spread over the Celestial soil, to deluge it with Bengali Tantrikism, and flooded the Indian peninsula, to tinge its Mussulmân Imperialism with Mongolian polity and art.

For if Asia be one, it is also true that the Asiatic races form a single mighty web. We forget, in an age of classification, that types are after all but shining points of distinctness in an ocean of approximations, false gods deliberately set up to be worshipped, for the sake of mental convenience, but having no more ultimate or mutually exclusive validity than the separate existence of two interchangeable sciences. If the history of Delhi represents the Tartar's imposition of himself upon a Mohammedan world, it must also be remembered that the story of Baghdad and her great Saracenic culture is equally significant of the power of Semitic peoples to demonstrate Chinese, as well as Persian, civilisation and art, in face of the Frankish nations of the Mediterranean coast. Arab chivalry, Persian poetry, Chinese ethics, and Indian thought, all speak of a single ancient Asiatic peace, in which there grew up a common life, bearing in different regions different characteristic blossoms, but nowhere capable of a hard and fast dividing-line. Islam itself may be described as Confucianism on horseback, sword in hand. For it is quite possible to distinguish, in the hoary communism of the Yellow Valley, traces of a purely pastoral element, such as we see abstracted and self-realised in the Mussulmân races.

Or, to turn again to Eastern Asia from the West, Buddhism— that great ocean of idealism, in which merge all the river-systems of

Eastern Asiatic thought—is not coloured only with the pure water of the Ganges, for the Tartaric nations that joined it made their genius also tributary, bringing new symbolism, new organisation, new powers of devotion, to add to the treasures of the Faith.

It has been, however, the great privilege of Japan to realise this unity-in-complexity with a special clearness. The Indo-Tartaric blood of this race was in itself a heritage which qualified it to imbibe from the two sources, and so mirror the whole of Asiatic consciousness. The unique blessing of unbroken sovereignty, the proud self-reliance of an unconquered race, and the insular isolation which protected ancestral ideas and instincts at the cost of expansion, made Japan the real repository of the trust of Asiatic thought and culture. Dynastic upheavals, the inroads of Tartar horsemen, the carnage and devastation of infuriated mobs—all these things, sweeping over her again and again, have left to China no landmarks, save her literature and her ruins, to recall the glory of the Tâng emperors or the refinement of Sung society.

The grandeur of Asoka—ideal type of Asiatic monarchs, whose edicts dictated terms to the sovereigns of Antioch and Alexandria—is almost forgotten among the crumbling stones of Bharhut and Buddha Gaya. The jewelled court of Vikramaditya is but a lost dream, which even the poetry of Kalidasa fails to evoke. The sublime attainments of Indian art, almost effaced as they have been by the rough-handedness of the Hunas, the fanatical iconoclasm of the Mussulmân, and the unconscious vandalism of mercenary Europe, leave us to seek only a past glory in the mouldy walls of Ajanta, the tortured sculptures of Ellora, the silent protests of rock-cut Orissa, and finally in the domestic utensils of the present day, where beauty clings sadly to religion in the midst of an exquisite home-life.

It is in Japan alone that the historic wealth of Asiatic culture can be consecutively studied through its treasured specimens. The Imperial collection, the Shinto temples, and the opened dolmens, reveal the subtle curves of Hang workmanship. The temples of Nara are rich in representations of Tâng culture, and of that Indian art, then in its splendour, which so much influenced the creations of this classic period—natural heirlooms of a nation which has preserved the music, pronunciation, ceremony, and costumes, not to speak of the religious rites and philosophy, of so remarkable an age, intact.

The treasure-stores of the daimyos, again, abound in works of art and manuscripts belonging to the Sung and Mongol dynasties, and as in China itself the former were lost during the Mongol conquest, and the latter in the age of the reactionary Ming, this fact animates some Chinese scholars of the present day to seek in Japan the fountain-head of their own ancient knowledge.

Thus Japan is a museum of Asiatic civilisation; and yet more than a museum, because the singular genius of the race leads it to dwell on all phases of the ideals of the past, in that spirit of living Advaitism which welcomes the new without losing the old. The Shinto still adheres to his pre-Buddhistic rites of ancestor-worship; and the Buddhists themselves cling to each various school of religious development which has come in its natural order to enrich the soil.

The Yamato poetry, and Bugaku music, which reflect the Tâng ideal under the régime of the Fujiwara aristocracy, are a source of inspiration and delight to the present day, like the sombre Zennism and No-dances, which were the product of Sung illumination. It is this tenacity that keeps Japan true

to the Asiatic soul even while it raises her to the rank of a modern power.

The history of Japanese art becomes thus the history of Asiatic ideals—the beach where each successive wave of Eastern thought has left its sand-ripple as it beat against the national consciousness. Yet I linger with dismay on the threshold of an attempt to make an intelligible summary of those art-ideals. For art, like the diamond net of Indra, reflects the whole chain in every link. It exists at no period in any final mould. It is always a growth, defying the dissecting knife of the chronologist. To discourse on a particular phase of its development means to deal with infinite causes and effects throughout its past and present. Art with us, as elsewhere, is the expression of the highest and noblest of our national culture, so that, in order to understand it, we must pass in review the various phases of Confucian philosophy; the different ideals which the Buddhist mind has from time to time revealed; those mighty political cycles which have one after another unfurled the banner of nationality; the reflection in patriotic thought of the lights of poetry and the shadows of heroic characters; and the echoes, alike of the wailing of a multitude, and of the mad-seeming merriment of the laughter of a race.

Any history of Japanese art-ideals is, then, almost an impossibility, as long as the Western world remains so unaware of the varied environment and interrelated social phenomena into which that art is set, as it were a jewel. Definition is limitation. The beauty of a cloud or a flower lies in its unconscious unfolding of itself, and the silent eloquence of the masterpieces of each epoch must tell their story better than any epitome of necessary half-truths. My poor attempts are merely an indication, not a narrative.

Notes

Bengali Tantrikism.—The Tantras are works written for the most part in Northern Bengal after the thirteenth century. Their subjects consist, very largely, of psychic phenomena and kindred matters, but they include some of the noblest flights of pure Hinduism. Their chief purpose seems to have been the formulation of a religion which could reach and redeem the lowest of the low.

Hàng Workmanship—Tàng Culture—Sung and Mongol Dynasties.—A brief abstract of the periods of Chinese history might run as follows:—

The Shu Dynasty (1122 to 221 B.C.).—This was the culmination of the process of early Chinese consolidation preceded by the dynasties of Kha and In. The capitals of these powers, though already situated in the valley of the Yellow River, were not yet advanced so far east as the present centre. They were placed westward of the Dokwan Pass, where the river makes a right angle in striking the plains, at that point where it was later to be touched by the Great Wall.
The Shin Dynasty (221 to 202 B.C.).—The tendency of this power to suppress communism brought about its downfall. The brevity of its duration, coupled with its importance, is only paralleled in modern times by the Empire of the first Napoleon.
The Hàng Dynasty (902 B.C. to 220 A.D.).—This empire was created by a popular rising. The headman of a village

became Emperor of China. But the whole trend and development of the Hângs grew to be imperialistic.

The Three Kingdoms (220 to 268 A.D.).—A territorial division.

The Six Dynasties (268 to 618 A.D.).—The Three Kingdoms were now consolidated under a single native dynasty, which had lasted about two centuries, when an influx of Hunnish and Mongolian tribes of the northern border drove them to take refuge in the valley of the Yang-tse. The scene of Chinese succession and culture is thus shifted at this period to the South, while the North becomes the means of the introduction of Buddhism and the establishment of Taoism.

The Tâng Dynasty (618 to 907 A.D.).—This dynasty was the result of the reconsolidation of China under the great genius of Taiso. The capital of the Tângs was on the Hoang-Ho, where the northern and the southern sovereignties were amalgamated. This combination was finally broken up by the feudalistic kingdoms, known as the Five Dynasties, which lasted, however, only half a century.

The Sung Dynasty (960 to 1280 A.D.).—The centre of rule was now again transferred to the Yang-tse. In this era, under the name of *Soju* or Sung scholasticism, is developed the movement which we have designated in the text as Neo-Confucianism.

The Gen or Mongol Dynasty (1280 to 1368 A.D.).This was a Mongolian tribe which, under Kublai Khan, overpowered the Chinese dynasty and established itself near Pekin. The Gen introduced Llamaism or Thibetan Tantrikism.

The Ming Dynasty (1368 to 1662 A.D.).—This was due to a popular uprising against the Mongol tyranny. It had its centre of power at Nankin, on the Yang-tse-Kiang; but it maintained a second capital, from the time of its third emperor, at Pekin.

The Manchu Dynasty (1662 to the present day).This was another Tartar tribe who took advantage of the division of power between the emperor and the army to establish themselves at Pekin. Having put down the rebellion of the generals, they could not again be dislodged. Their lack of complete identification with the nation has been the weakness of this house, and rebellions against their power have arisen always on the Yang-tse.

Yamato Poetry.—The word *Yamato* is used here as a synonym for *Ama*, the primitive stock of the Japanese. It is also the name of a province in Japan.

Bugaku Music.—This means dance music—from *bu*, to dance, and *gaku*, music, or to play. This bugaku music in Japan was developed in the Nara-Heian period, under the influence of the Chinese culture of the Six Dynasties. It was formed of combined elements of Indian and old Hâng music. It is played by a hereditary caste of musicians called *Reijiu*, who are attached to the Imperial court, and to grand monasteries and Shinto temples, like Kusaga, Kamo, and Tennoji. It is to be heard on great occasions of festivity and ceremonial.

The Primitive Art of Japan

The origin of the Yamato race, who drove the aboriginal Ainu before them into Yezo and the Kurile Islands, in order to establish the Empire of the Rising Sun, is so lost in the sea-mists out of which they sprang, that it is impossible to divine the source of their art-instincts. Whether they were a remnant of the Accadians who mingled their blood with that of Indo-Tartaric nations, in the passage along the coasts and islands of south-eastern Asia; or whether they were a division of the Turkish hordes who found their way through Manchuria and Korea to settle early in the Indo-Pacific; or whether they were the descendants of the Aryan emigrants who pushed through the Kashmirian passes, to be lost amongst the Turanian tribes forming the Thibetans, Nepalese, Siamese, and Burmese, and to bring the added power of Indian symbolism to the children of the Yang-tse-Kiang valley, are questions still in the clouds of archæological conjecture.

The dawn of history reveals them as a compact race, fierce in war, gentle in the arts of peace, imbued with traditions of solar descent and Indian mythology, with a love of poetry, and a great reverence for womanhood. Their religion, known as Shinto, or the Path of Gods, was the simple rite of ancestor-worship—honouring

the manes of the fathers who were gathered to the groups of Kami or gods, on the mystic mountain Takamagahara, the highland of Ama—an Olympus which had the Sun-Goddess as its central figure. Every family in Japan claims descent from the gods who followed the grandson of the Sun-Goddess in his descent upon the island, by the eight-rayed pathway of the clouds, thus intensifying the national spirit which clusters round the unity of the Imperial throne. We always say "We come of Ama," but whether we mean the sky, or the sea, or the Land of Rama (?) there is nothing, save the simple old rites of the Tree, the Mirror, and the Sword, to tell.

The waters of the waving rice-fields, the variegated contour of the archipelago, so conducive to individuality, the constant play of its soft-tinted seasons, the shimmer of its silver air, the verdure of its cascaded hills, and the voice of the ocean echoing about its pine-girt shores—of all these was born that tender simplicity, that romantic purity, which so tempers the soul of Japanese art, differentiating it at once from the leaning to monotonous breadth of the Chinese, and from the tendency to overburdened richness of Indian art. That innate love of cleanness which, though sometimes detrimental to grandeur, gives its exquisite finish to our industrial and decorative art, is probably nowhere to be found in Continental work.

The temples of Isé and Idzumo, sacred shrines of immaculate ancestrism, with their toris and rails so reminiscent of Indian torans, are preserved in pristine exactness by having their youth renewed every two decades in their original forms—beautiful in their unadorned proportions.

The dolmens, whose shapes are significant, in their relation to the original stupa, and suggestive as the prototype of the lingam, hold stone and terra-cotta coffins of fine form, covered

sometimes with designs of considerable artistic merit, and containing implements of worship and personal decoration, which display highly finished workmanship in bronze, in iron, and in various-coloured stones. The terra-cotta figurines placed round the burial mound, and supposed to represent more ancient human sacrifices at the grave, often attest the artistic ability of the primitive Yamato race. Yet the influx of the matured arts of the Hâng dynasty of China, which reached us in this early stage, overwhelmed us with the wealth of an older culture, and completely absorbed our æsthetic energy in a new effort on another and higher plane.

What Japanese art would have been if our civilisation had stood bereft of this Hang influence, and of the Buddhism which reached us later, it is difficult to imagine. Who dares to conjecture what Greece might have failed to attain, notwithstanding her vigorous artistic instinct, had she been deprived of the Egyptian, the Pelasgian, or the Persian background? What would not have been the bareness of Teutonic art, if divorced from Christianity, and from contact with the Latin culture of the Mediterranean races? We can only say that the original spirit of our primitive art has never been allowed to die. It modified the tilted roofs of Chinese architecture by the delicate curves of the Kasuga style, in Nara. It imposed their feminine refinement on the creations of Fujiwara. It impressed the purity of the sword-soul on the solemn art of Ashikaga. And as the stream courses on under masses of fallen foliage, it still ever and anon reveals its brilliance, and feeds the vegetation by which it is concealed.

Apart from this, her unassailable original destiny, the geographical position of Japan would seem to have offered her the intellectual rôle of a Chinese province or an Indian colony. But the rock of our race-pride and organic union has stood firm

throughout the ages, notwithstanding the mighty billows that surged upon it from the two great poles of Asiatic civilisation.

The national genius has never been overwhelmed. Imitation has never taken the place of a free creativeness. There has always been abundant energy for the acceptance and re-application of the influence received, however massive. It is the glory of Continental Asia that her touch upon Japan has made always for new life and inspiration: it is the most sacred honour of the race of Ama to hold itself invincible, not in some mere political sense alone, but still more and more profoundly, as a living spirit of Freedom, in life, and thought, and art.

It was this consciousness that fired the warlike Empress Zhingu to brave the seas, for the protection of the tributary kingdoms in Korea, in face of the Continental Empire. It was this which dismayed the all-powerful Yodai, of the Zui dynasty, by calling him "Emperor of the Land of the *Setting* Sun." It was this which defied the arrogant menace of Kublai Khan in the full zenith of a victory and conquest that was to overpass the Ural ranges into Moscow. And it is for Japan herself never to forget that it is by right of this same heroic spirit that she stands to-day face to face with new problems, for which she needs still deeper accessions of self-reverence.

Notes

The simple old rites of the Tree, the Mirror, and the Sword.—The tree referred to is the Sakaki, or tree of the gods., upon which are hung pieces of brocade, silk, linen, cotton and paper, cut in special devices. The Mirror and the Sword form part of the Imperial insignia, handed on by the Sun-goddess to her grandson when he descended upon the islands. Shinto shrines contain

nothing but a mirror. The Sword, supposed to have been taken from the tail of a dragon killed by Susasmo, the Storm-God, is specially worshipped at Atsuta.

The temples of Isé and Idzumo.—The temple of Isé is the shrine of the Sun-Goddess. It is in the district of Yamada, in the province of Isé, in Central Japan. The temple of Idzumo is the shrine of the descendants of the Storm-God, who were sovereigns of Japan before the descent of the grandson of the Sun-Goddess on the country. It is situated in the province of Idzumo, on the northern coast of Japan. The temples of Isé and Idzumo are built entirely of wood, and each has two alternative sites, on one of which it is rebuilt, in the exact original form, every twenty years. The style is suggestive of development from the architecture of the bamboo cottage, or the log hut, still to be seen in great numbers on the south-eastern coast of Asia. It does not suggest a tent.

The Kasuga Style in Nara.—The Kasuga style is a development of the Shinto style of Isé and Idzumo. It is characterised by very delicate curves, which take the place on the one hand of the straight lines of Yamato architecture, and on the other of the exuberant canvas-like curves of the Chinese.

The arrogant menace of Kublai Khan.—Kublai Khan, after his conquest of China, sent an embassy, calling upon Japan to surrender. A peremptory refusal was followed by an invasion of some of the outlying islands. Then, while the Japanese waited, guarding their coasts, a great cloud was seen to rise at night from the temple of Isé, and, in the storm which resulted, the fleet of the invaders, with its ten thousand ships and million men, was

utterly destroyed, only three men escaping with their lives. This was the divine wind of Isé, and to this day each sect claims that it was raised by the power of its supplication. This is the only occasion in history on which the rulers of China adopted an aggressive policy towards Japan.

Confucianism—Northern China

THE first wave of continental influence which swept over the art of primitive Japan, before Buddhism reached us in the sixth century, was that of the Hâng and the Six Dynasties of China.

Hâng art was itself the natural outcome of a primeval Chinese culture, which had culminated under the Shu dynasty B.C. 1122 to B.C. 221, and its idea may be broadly termed Confucian, from the name of the great Sage who embodied and elucidated the fundamental notions of the Celestial race.

For the Chinese—who are agricultural Tartars, just as the Tartars are nomadic Chinese—in settling, untold ages earlier, in the rich valley of the Yellow River, had begun at once to evolve a grand system of communism, entirely distinct from the civilisation of their wandering brethren, left behind them on the Mongolian steppes, though no doubt even in that earliest phase, amongst the cities in their kingdoms of the plateaux, some congenial elements had existed, suited to become the germ of the Confucian development. From this moment, lost as it is in prehistoric night, to the present day, the function of the Yellow River peoples has been one and the same, in the midst of their own progressive development, to receive periodically fresh

increments of Tartar nomads, and assimilate them to a place in the agricultural scheme.

This is a process which, by beating the sword of the nomad into the ploughshare of the peasant, weakens the resistive powers of the new citizen, and leaves him to suffer again "behind the walls" the fate he once inflicted from without. Thus the long succession of Chinese dynasties is always the story of the rise of some fresh tribe to the head of the state, to be again supplanted, when the old conditions are repeated.

For many ages after their settlement on the plains, however, the Chinese Tartars still retained a pastoral notion of government, the governors of the nine provinces into which early China was divided being called *Boku* or *pastors*. They believed in a patriarchal God, symbolised by *Ten* or Heaven, who, in His benevolence, rained destinies in mathematical order on mankind, probably, since the Chinese word for *Fate* is *Mei* or *Command*, the root idea of that fatalism which, lent to the Arabs by the Tartars, became Mohammedanism. They maintained still their dread of the various wandering spirits of the unseen world, their idealism of womanhood, which was to develop later into the zenana-life of the East; that knowledge of the stars which they had gathered, with the dualistic mythology of the Turanians, as they wandered amongst the tall grasses of the plateaux; above all, the grand idea of a universal brotherhood, inalienable heritage of all the pastoral nations who roam between the Amoor and the Danube. This fact, that in China the peasant was preceded by the shepherd, is expressed in their mythology by saying that the first emperor was Fukki, the Teacher of Grazing, succeeded by Shinno, the Divine Farmer.

But the slowly-defining necessities of an agricultural community, developing itself through uncounted ages of tranquillity,

were yet to bring forth that great ethical and religious system, based on Land and Labour, which to the present day constitutes the inexhaustible power of the Chinese nation. True to this, their ancestral organisation, and self-contained in its exalted socialism, its children, in spite of political disturbances, go on now spreading their industrial conquest to all available corners of the globe.

It fell to the lot of Confucius (B.C. 551 to B.C. 479), at the end of the Shu dynasty, to elucidate and epitomise this great scheme of synthetic labour, worthy of study by every modern sociologist. He devotes himself to the realisation of a religion of ethics, the consecration of Man to Man. To him, Humanity is God, the harmony of life his ultimate. Leaving the Indian soul to soar and mingle with its own infinitude of the sky; leaving empiric Europe to investigate the secrets of Earth and matter, and Christians and Semites to be wafted in mid-air through a Paradise of terrestrial dreams—leaving all these, Confucianism must always continue to hold great minds by the spell of its broad intellectual generalisations, and its infinite compassion for the common people.

The *Eki* or *Book of Change*, Veda of the Chinese race, full of allusions, as it is, to the pastoral life, though by it he approaches the Incomprehensible, is almost a forbidden page to the agnostic Confucius, who says, "Knowing not yet of life, how am I to talk of death?" According to Chinese ethics, the unit of society is the family, constituted on the system of graduated obedience, and the peasant is of equal importance with the emperor—that parental autocrat whose virtues have placed him at the head of the great communistic brotherhood of mutual duties, entirely by its own consent and choice.

The supreme canon of life was the self-sacrifice of the individual to the community, and art was prized for its service to the moral deeds of society. Music, it is to be noted, was placed in the highest

rank, its special function being to harmonise men with men, and communities with communities. The study of music was therefore the first accomplishment of a Shu youth of gentle blood.

There are some who will recall in the life of Confucius, not only the several dialogues in which he dwells lovingly on its beauty, but also the stories of his choosing to fast, rather than forego the hearing of music, of his following a child on one occasion who was beating an earthen pot, simply for the pleasure of watching the effect of the rhythm on the people, and finally of his journey to the province of Sei (Shantung) in the enthusiasm of his desire to hear the ancient chants which were there extant, handed down from the days of Taiko-bo.

Poetry, in like manner, was regarded as a means of conducing to political harmony. It was not the province of the prince to command, but to suggest, nor the aim of the subject to remonstrate, but to hint, and of all this poetry was the recognised medium. This is a theory which implies that, just as in mediaeval Europe, the folk-songs of countrysides, with their burden of love, and labour, and the beauty of earth; the ballads of border-warfare, echoing the clang of weapons and the trampling of excited steeds; and weird chants of the supernatural, on the borderland of the realm where ignorance bows before the Infinite—were its accepted form. For such a doctrine could only be formulated in an age rich in such elements, and by a people amongst whom the poetry of individual self-realisation was not yet born. Ancient ballads were collected by the Sage by way of illustrating the manners of the Chinese Golden Age, of the three early dynasties of Kha, In, and Shu, when its songs furnished the test by which the welfare or misgovernment of a province was to be determined.

Even painting was held in esteem for its inculcation of the practice of virtue. The Sage, in his family dialogues, speaks

of visiting the mausoleum of the kings of Shu, and describing how on the wall was a portrait of Shuko, bearing in his arms the infant King Seiwo, he contrasts this with another picture of Ketsu and Chu, despotic tyrants of the past, shown in the act of personal enjoyment, and dwells on the glory and meanness depicted in the respective delineations.

It may be said of the Shu vases and other bronzes that, although they followed a different convention, they are more than equal in purity of form to the Greek. Indeed, these together constitute, like the calm and delicate jade, compared with the flashing individualistic diamond, the antithesis of ideals, the two poles, of the decorative impulse in East and West. And here also, amongst the workers in metal and jade, we find the same passionate effort to realise the ideal of harmony that absorbs the singers and painters of the period.

The consolidated Shu power had lasted some five hundred years, when it was weakened by the rise of strong feudal houses, which were again conquered and finally absorbed about the year 221 B.C., according to the perpetual destiny of China, by a tribe from the out-lands known as *Shin*, whose importance had been increasing during some six hundred years. These were Mongolian herdsmen, who had been horse-breeders and charioteers under the first emperors of Shu, and who now, as the last-comers from the desert, became the dominant element. From their territories, lying on the frontiers of the empire, it is supposed that the name by which foreigners know the Celestial soil is taken.

To these tyrants ancient Confucian scholars attributed every conceivable abomination and terror. But it may be held that they were, after all, an integral factor in the working out of the Shu system. It was by them that the Chinese Empire was consolidated, with its roads and great walls, its provincial governments

akin to the Persian satrapies, and its invention, or more correctly its choice, of a national system of chirography. It was they who formally disarmed China, and it was they who first assumed the style and title of emperors. In all this it may be that they only followed the common tradition of imperialism, which provides for its own purposes that centralisation by which it is afterwards to be overthrown.

Even their antipathy and persecution of letters may be considered as not necessarily directed against Confucian scholars so much as towards the suppression of free political thought—a dangerous element in the feudalistic kingdoms of the latter part of the Shu power. They had national schools, but only under instructors called Hakushi, appointed by the Government.

This was the age of wide philosophic thought the world over. Buddhism was becoming a social consciousness. Athens was a living influence. Christianity was about to dawn on mankind at Alexandria. And on the eastern side of the great ranges, the era of the Shin tyrants was rich in schools. They practised a censorship which is known as the "Fire of Shin," but it is probable that the destruction of literature, so greatly lamented by posterity, was not in fact due to this so much as to the civil war, which raged for twenty years, during the downfall of their short empire.

The Hâng dynasty (202 B.C. to 220 A.D.) succeeding the Shin, followed in the main their policy, with the one difference that from the time of their third emperor they made a knowledge of Confucianism compulsory in the civil service examinations, a regulation which has come down to the present day. This system was very helpful in drawing the best intellect of the country to the service of the state, and yet, the critical element in the test being fixed, growth and evolution were checked, and Confucianism itself tended to become rigid.

So strong, indeed, was the influence of Confucian thought at this period that in the first century of the Christian era a prime minister, Omo by name, ascended the Dragon Throne in its authority, asserting the choice of the wise men of the time, according to the tradition which it upheld.

This man, it is interesting to note, was of remarkable genius. He established the dynasty of Shin, and it is supposed, from the fact that during his short reign of fourteen years his coins reached all parts of the known world, that it was then that the name of China (Shin-land) was first given. It is probable, however, from the earlier occurrence of the name in Indian literature, that he only reinforced its use. He has the distinction of being the first sovereign in history to publish an edict abolishing slavery, and his downfall only occurred when he allowed his Confucian instincts to carry him to the point of proclaiming, and attempting to effect, equal division of the land amongst all the people. This concentrated the power of the nobles against him, and he was killed in the year 23 A.D. The story of his death is a superb instance of the fatalism natural to the Confucian mind. He sat in his palace, jade staff in hand, gazing out upon the stars, while the battle raged round his standards without. "If it be the will of Heaven I shall die; if not, nothing can kill me," he said calmly, and his assassins rushed in upon him and killed him, unresisting, as he sat. His name is still surrounded by the aroma of that courtesy with which he received the foreign embassies.

The art of the Hângs—who spread Confucian ideals as the Romans did Hellenic culture—was Shu-ist in form, though tinged by that richer colouring and magnificent imagery which were an integral part of the Hâng consciousness, with its vast unification and luxurious life. In literature one notes with interest that its writers are always striving to find an ethical basis for

this, the gorgeous colouring of their stupendous indulgence, and do so from a standpoint of remarkable social intelligence. Any Chinese scholar will recall the rhymed prose of Shibasojo and Soshimon, where, after depicting the wonderful hunting-parties of the emperor, with their glittering chariots, their elephants and lions, brought from distant realms, their banquets and dancers, they add, "We are indeed happy that the times are so peaceful, for thus kings may afford such luxury!" Again, they enumerate the glories of the principal cities of the empire, and end by suggesting that the true beauty of a capital lies rather in the happy faces of its people than in the towers and ornaments upon its buildings.

The architecture of the period is characterised by gigantic palaces, adorned with caryatided pillars and profuse carving, representative chiefly of the moral life. Stupendous towers, and great structures in wood and brick, were erected by these true successors of the Shin. For it was the era of military walls, and, like the Romans after them, the Shin emperors had left their memorial in the Great Wall that stretches from Dokwan to the Yellow Sea. It may, indeed, be held that this, the culmination, had also been the beginning of the decadence of their power, exhausting alike the resources and the prestige of their government. But many succeeding dynasties added to the work. Other architectural achievements of this period, however, like the colossal statues in bronze and iron, of which such frequent mention is made in letters, are now lost, partly because Chinese emperors have had the habit of burning themselves with their treasures in the hour of defeat, and partly by the vandalism of dynastic changes.

The pictorial style of the Hângs is, of course, irrecoverable, unless we can conjure up its richness and maturity from the roughly-chiselled rocks of the Burioshi in Shantung, tombs of

a family of provincial nobles, who belonged to the latter part of the Hâng dynasty. These fresco-sculptures contain descriptions of Chinese mythology and history, and show the life and customs of early China.

In order to find specimens of the wonderful crafts of the period, we have to turn to Japan, to the collections of the imperial family, to the treasuries of Shinto temples, and to the unearthed contents of the dolmens. For we received Hâng art from China, and were even perhaps acquainted with Chinese literature, long before Wani the Hakushi, the Korean scholar, came to expound Confucian texts. That there was a prior stream of influence is attested by the numerous inscriptions in Chinese, showing the facility with which that language was cultivated, not long after his advent. Thus in Japan, as in China, Confucianism provided the soil on which the seed of Buddhism afterwards fell.

The vast bulk of Chinese and Korean immigrants were artists and artisans, who worked in the Hâng style, as their mirrors, horse-trappings, sword-ornaments, and beautiful armour in bronze and gold will testify. Thus the art-education of the Japanese was almost complete by the time Buddhism called for a new and grand expression in the Asuka Period. The genius of Toribushi, our great sculptor, was not born in a night, but was the fruit of causes long pre-existent; and in him we have only the first harvesting of a mighty culture that had covered the ploughlands for many a day.

Yet the Confucian ideal, with its symmetry born of dualism, and its repose, the result of the instinctive subordination of the part to the whole, was necessarily restrictive of the freedom of art. Enchained to the service of ethics, art naturally became industrial. Indeed, the Chinese art-consciousness must always have tended towards the decorative—as shown in its extraordinary development

of textiles and ceramics—had the Taoist mind not imparted to it its playful individualism, and had Buddhism not come later, to lift it up to the expression of commanding ideals. But even if it had remained at the decorative, it could never have sunk to the bourgeois level, since from the remotest danger of such a failure of sympathy, Asiatic art, by her vast life of the Universal and Impersonal, stands eternally redeemed.

Notes

Eki or Book of Change.—The ancient Scripture of China, which was accumulated gradually through the periods of Kha and In, and attained to its present form under Bunno, the first King of Shu. Confucius added a commentary, which is considered an essential feature of Eki by Confucians. Here much is made of Man, as the central point between the conflicting forces of Heaven and Earth, thus philosophising communism. The Taoist, on the other hand, is able to ignore the Confucian commentary and interpret Eki in his own way. To him, its great note is the text, "Open matter and create work." This ancient Chinese Veda may be described as a philosophy of Nature, rather than a story of Creation. It deals with the immanence of One in all duality, and with the relation of the four seasons or Heaven to the eight elements or Earth. It consists of four books or divisions.

The Ancient days of Taiko-bo.—Taiko-bo was the chief counsellor of the first King of Shu, when the throne was taken from In. This great minister was rewarded by being made King of Sei (Shantung).

Laoism and Taoism—Southern China

Confucian China could never have accepted Indian idealism had not Laoism and Taoism, ever since the end of the Shu dynasty, been preparing a psychological basis for the common display of these, the mutual polarities of Asiatic thought.

The Yang-tse-Kiang is no tributary of the Hoang-Ho, and the all-grasping socialism of agriculturalised Tartars, bred on the banks of the Yellow River, had never been enough to enthral the wild spirits of their brethren, the children of the Blue River. Amongst the impenetrable forests and misty swamps of that great valley dwelt a race fierce and free, owning no allegiance to the kings of Shu is of the northern provinces. The chiefs of these mountaineers, in feudal days, were not admitted to the assembly of the Shu nobles, and their uncouth appearance and rough language, compared by the northerners to the croaking of ravens, were matters of ridicule, even as late as the period of the Hâng dynasty. But, gradually impregnated with Shu culture, these southern people found art-expression of their own loves and ideals, in forms widely divergent from those of their northern countrymen.

This poetry, as exemplified in Kutsugen, of tragic memory, abounds in the intense adoration of nature, the worship of great

rivers, the delight in clouds and lake-mists, the love of freedom, and the assertion of self. The last point finds striking illustration in the *Tao-tei-king*, or *Book of Virtue*, of Laotse, the great rival of Confucius. In this work, five thousand ideographs long, we hear of the greatness of retiring into self and freeing ego from the trammels of convention.

Laotse, who was born in the then southern province of So, and was custodian of the Shu archives, was revered as a master by Confucius, in spite of the difference of their doctrines, and describes him in turn as "the dragon," saying, "I know that fish can swim, I know that birds can fly, but the dragon's power I cannot gauge." Laotse's successor, Soshi, also a Southerner, followed in his footsteps, and enlarged on the relativity of things and mutability of forms.

The book of Soshi, rich in splendid imagery, is in great contrast to the Confucian works, with their dry and prosy maxims. He speaks of the bird of magic, whose wings are ninety thousand miles long, whose flight darkens the sky, and which takes half a year till it alights. Meanwhile, thrushes and sparrows twitter in their amusement, "Rise we not up from the grass to the tree-tops in a moment? What is the use of this great long flight?" Again, "The wind, Nature's flute, sweeping across trees and waters, sings many melodies. Even so, the Tao, the great Mood, expresses Itself through different minds and ages and yet remains ever Itself." Or again, "The art of living, whose secret lies not in antagonisms or criticisms, but in gliding into the interstices that exist everywhere." This last point he illustrates by the master-butcher, whose knife never needed sharpening, since he cut between the bones, instead of attacking them. Thus he ridicules the Confucian polity and conventions, which are but finite efforts, and can never cover the great range of the impersonal Mood.

It is said that he was asked to take office, but he pointed to a bull, decorated for sacrifice, saying, "Thinkest thou that the beast will feel happy when the axe is on him, though he be bejewelled?" This spirit of individualism shook Confucian socialism to its very foundations, so that the life of Mencius, the next great Confucian after the Master, was devoted to fighting the Laoist theories. It will be noticed that in this Eastern struggle between the two forces of communism and individual reaction, the ground of contest is not economic but intellectual and imaginative. None would have been more desirous of protecting the great moral advantage won by Confucius for the common good than Laotse, who was a rival thinker.

In the sphere, also, of statecraft, the Southern mind produced great thinkers, quite opposed to the Confucian ideals. Here, for instance, Kampici, sixteen centuries before the Italian wrote "The Prince," elaborated the system of Machiavelli. The period was prolific of military theory; a Napoleonic genius was devoted to the elaboration of the science of tactics. For the feudal age at the close of the Shu dynasty was one of free discussion. Original thought and research were welcomed on politics, sociology, and law, while the liberty and complexity of the Southern Chinese nature enabled it to rise to the height of the opportunity.

All this time China was being gradually eaten by the encroachments of the Shin, and after the change of dynasties their imperialism and the Confucianism of Hâng seemed likely to prove fatal to the Laoist school. But the stream of philosophic energy found an underground channel, from which it emerged, towards the end of the Hâng period, in the freedom and vagaries of the Conversationalists.

In the three kingdoms into which the Hâng dynasty divided—thus lessening the prestige of Confucian unity—the

spirit of Laoism was rampant. New commentaries on the *Tao-tei-king* were written by Kaan and Ohitsu, and though such thinkers did not openly attack Confucianism, yet their lives were consciously directed as demonstrations against convention. This was the period when learned men retired to discuss philosophy in bamboo groves; when a prime minister chose to stop his coach before a roadside tavern in order to drink with his servants in the sight of the astonished public; when a simple student ventured to delay a high dignitary and ask him to play on the flute, for which he was noted, the amiable statesman being pleased to indulge him in his request for hours; when philosophers would betake themselves, for amusement's sake, to work at the forge, paying no attention to the illustrious guests who might have come to honour them by putting weighty questions for solution. The poetry of this era and of the early part of the Six Dynasties (265 to 618 A.D.) represents this freedom, and by the simplicity and grace with which it returns to the love of Nature, stands in strong contrast to the gorgeous imagery and elaborate metres of the Hâng poets.

Every one will remember the poems of Toenmei—most Confucian of Laoists and most Laoist of Confucians, the man who resigned a governorship because he disliked wearing a ceremonial robe to receive an imperial representative—for his ode on "The Return" was the very expression of the times. It is through Toenmei and other poets of the South that the purity of the "dew-drooping chrysanthemum, the delicate grace of the swaying bamboo, the unconscious fragrance of plum-flowers floating on the twilight water, the green serenity of the pine, whispering its silent woes to the wind, and the divine narcissus, hiding its noble soul in deep ravines, or seeking for spring in a glimpse of heaven, become themes of poetic inspiration, which,

when blended with Buddhist ideals in the great liberalising Tang period, bursts forth again in the Sung poets, who are, like Toenmei, a product of the Yang-tse mind, ever seeking the expression of the soul in Nature.

Freedom is recognised as the essential characteristic by Soshi. He relates a story of a great noble who sought for a distinguished painter to execute a picture. One by one the candidates arrived, and, saluting him decorously, inquired as to the subject and manner of treatment required by him. With all this he was far from satisfied. At last an artist appeared, who burst rudely into the room, and throwing off his garments sat down in some rough posture before calling for his brushes and colours. "Here," exclaimed the patron, without further ado, "I find my man!"

Kogaishi was a poet-painter, of the latter part of the fourth century, who belonged to the Laoist school, and was held admirable for three virtues, being called "first in poetry, first in painting, and first in foolishness." His is the earliest voice to speak of the necessity of concentration on the dominant note, in an art-composition. "The secret of portraiture," he said, "lies in *that*, revealed in the eye of the subject." For it is another fruit of the Laoist mind that the first systematic criticism of painting and the first history of painters were begun in China at this period, so giving the basis for a future generalisation of æsthetics in that land and in Japan.

Shakaku in the fifth century lays down six canons of pictorial art, in which the idea of the depicting of Nature falls into a third place, subservient to two other main principles. The first of these is "The Life-movement of the Spirit through the Rhythm of Things." For art is to him the great Mood of the Universe, moving hither and thither amidst those harmonic laws of matter which are Rhythm.

His second canon deals with composition and lines, and is called "The Law of Bones and Brush-work." The creative spirit, according to this, in descending into a pictorial conception must take upon itself organic structure. This great imaginative scheme forms the bony system of the work; lines take the place of nerves and arteries, and the whole is covered with the skin of colour. That he ignores the question of dark and light, is due to the fact that in his day all painting was still on the early Asiatic method—covering the ground with white lime and laying upon this the rock-pigments, which were accentuated and marked off from each other with strong black lines. Thus Confucius says "all painting is in the sequence of white." We find the same method employed in the wall-paintings of Ajanta in India, and Horiuji in Japan.

Face to face with these, the dream of the great lost style of the Greeks in painting,—that style which was theirs before a stage chiaroscuro and imitation of Nature were brought in by the Appellesian school—rises up before us, with an ineffaceable regret. We think of the "Cassandra" of Protogenes, that master of strong line, who could, as they say, give the whole fall of Troy in the eyes of the prophetess, and we cannot refrain from saying that European work, by following the later school, has lost greatly in power of structural composition and line expression, though it has added to the facility of realistic representation. The idea of line and line-composition has always been the great strength of Chinese and Japanese art, though the Sung and Ashikaga artists have added the beauty of dark and light-without forgetting that the artistic, and not the scientific, was their goal—and the Toyotomi epoch has contributed the notion of composing in colour.

The sacredness of calligraphy, which attains to great heights for the first time in this Laoist period, is the worship of the line, pure and simple. Each stroke of the brush contains in itself its principle of life and death, inter-related with the other lines to form the beauty of an ideograph. It must not be thought that the excellence of a great Chinese or Japanese painting lies only in its expression or accentuation of outlines and contours, nevertheless these do, as simple lines, possess an abstract beauty of their own.

As no works of the Laoist period are now extant, we are left to infer and reconstruct their style from those of the succeeding epoch which still retain their characteristics. We know that a new range of subjects has been attempted. The love of Nature and Freedom of this great school have led them to landscape, and we read of their pictures of the wildfowl calling to each other amongst the reeds. Above all, they bring forth the mighty conception of the Dragon, that awful emblem, born of cloud and mist, of the power of Change, and in their tiger-and-dragon pictures they portray the ceaseless conflict of material forces with the Infinite—the tiger roaring his incessant challenge to the unknown terror of the spirit.

As was natural, the masses of the people could not be carried by the Laoist movement. Neither Laotse-Soshi, nor their legitimate descendants, the Conversationalists—delighting in their learned discussions about the Abstract and Pure, waving the jade-handled yak-tails as they talked—can be held responsible for that cult known as Taoism, which holds so much of the Chinese race in its hands today, and claims "the old Philosopher" as its founder.

In spite of the steady efforts of Confucian sages, the Tartar superstitions which came with the Chinese from their early

home, could never be eradicated, and the uncultivated forest-
ers of the Yang-tse-Kiang were the guardians of this primitive
inheritance, delighting in demoniac stories of witchcraft and
magic. Indeed, a necessary outcome of Confucianism itself,
ignoring as it did the problem of an after life, and stating that
the higher elements in man would return to heaven, and his
lower be united once more in the earth, was the quest of immor-
tality in the flesh.

Even so far back as the late, Shu literature, we find frequent
mention of the Sennin, or Wizard of the Mountains, who
by strange practices, and the discovery of a magic elixir, has
attained the power of living for ever, and now spends his time
riding through the mid-day sky on the backs of storks to join
the secret meetings of his mysterious brotherhood.

The emperors of Shin sent out expeditions to search for the
potion of immortality in the Eastern seas, and the members,
afraid to return empty-handed, are believed to have settled in
Japan, where whole families claim descent from them to the
present day.

The Hâng emperors, too, were not unaddicted to similar
pursuits, and time after time erected palaces of worship for their
gods, which were invariably overthrown by Confucian protest.
Their experiments in alchemy, however, were productive of many
compounds, and we may ascribe the origin of the wonderful
porcelain-glaze of China to their accidental discoveries.

But the final organisation of Taoism as a sect was due to the
labours of Rikujusei and Sokensi in the early part of the Six
Dynasties. They adopted the philosophy of Laotse and the ritual
of the Buddhists, with the idea of increasing the significance and
sanction of the popular notions. And it was they who initiated
the awful series of persecutions which were so disastrous to the

Buddhists of Northern China, before the liberalism of the Tâng dynasty enabled Confucians, Buddhists, and Taoists to live side by side in mutual toleration.

On its philosophic side Buddhism was received with open arms by the Laoists, who found in it an advance on their own philosophy. The early teachers of the Indian doctrine in China were mostly students of Laotse and Soshi. And Yéon even taught these books as a necessary preparation for the understanding of the abstract idealism of Ashvaghosha and Nagarjuna.

From its more concrete aspect, again, the early Taoists welcomed the images of Buddha as those of one of their own gods. The golden Sennin (Wizard of the Mountains) which Hanchow, one of the Hâng generals, brought back as a trophy from an inroad on the borders of Thibet in the first century, was considered, as the name implies, nothing different from the Taoist images already extant in China, so that it was put amongst the Taoist deities and worshipped with similar rites in the Kansen palace, or Hall of Sweet Springs.

The King of So, in the second century of the Christian era, being a pronounced Taoist, was also at the same time a devout Buddhist. In the third century, when the Emperor Korei cast an image of Buddha in gold he cast at the same time an image of Laotse. All this proves that in this early period the two religions were not defiant, as later Taoist works assert.

Notes

Kutsugen.—A prince of So, a province on the Yang-tse. His counsels were rejected by the King of So, and he was exiled. By way of self-assertion he wrote great poems of solitude—of the man who stands apart from men—seeking in Nature his

only friend, in idealisation his only home, and then committed suicide by drowning. To this day his death is mourned annually by great concourses of people.

Mencius.—Moshi or Mencius lived about a century after Confucius. With Bunno and Confucius benevolence had been preached as the secret of human association. Mencius adds the note of duty, depicting mutual obligation as the law. The ideograph for duty is very suggestive here; it consists of sheep and ego. *My sheep*, that is, duty. The ideograph for benevolence is man and two-in two, one forgets oneself.

The Dragon.—Since the rise of Taoism, throughout Chinese and Japanese art, whenever infinity is to be expressed, we find this symbol. It signifies the power of Change—the supreme sovereignty. The imperial person may always be described as the Dragon-bodied or the Dragon-faced.

Buddhism and Indian Art

Buddhism is a growth. The diamond-throne of the original enlightenment is now difficult indeed to discover, surrounded as it is by the labyrinth of gigantic pillars and elaborate porticos which successive architects have erected, as each added his portion to the edifice of faith. For there has been no generation that did not bring its own stones and tiles to widen the great roof that, like the bodhi-tree itself, offers every day a broader shelter to mankind. As in Buddha Gaya, it is the obscurity of centuries that hides the image of the birth of Buddhism. Garlands of love and reverence have covered it, and sectarian pride and pious frauds have stained, each to his own hue, the waters of the surrounding ocean, till it is almost impossible to distinguish between the various streams and currents once its tributaries.

Yet it is this very power of adaptation and growth that constitutes the greatness of that system which not only embraces Eastern Asia, but bore its seeds long ago to blossom in the Syrian desert, and in the form of Christianity completes the circling of the world, with its fragrance of love and renunciation.

The several forms which the thought of the great Teacher has assumed, as it has come in contact with various nationalities and periods—even as the same raindrops may call to life the flowers

of many different climes—are indeed difficult to analyse and describe in their true order of development. For Asia is vast, India itself larger than Europe west of the Vistula, and the twenty-three Indian, twelve Chinese, and thirteen Japanese schools, with their innumerable subdivisions, under which later students love to classify the formulations of Buddhism, are inter-related more in the sense of territorial distribution than of chronological succession. Their very names, Northern and Southern, imply that this is so with the two main divisions of the faith.

In religions that are ascribed to individual founders, it is clear that there must be two great elements—one the gigantic figure of the Master himself, growing ever more dazzling as successive centuries reflect their own brightness on his personality, and the other, the historic or national background, out of which he springs to consciousness. If we go deeper into the psychological conditions of the sense of individuality, we shall think it reasonable to look for a certain antithesis, though not necessarily any antagonism, between the Teacher and his past. Those elements of his realisation which he does not discover in the social consciousness will be the subject of his most forcible utterance. And yet only in its relation to that consciousness will his message reach its full significance. It is, therefore, quite conceivable that the doctrine of the Founder, carried away from its natural environment, may be understood and developed in some sense, true in itself, and yet superficially contradictory of another stream of thought which is at least as authentic and vastly more faithful to the complexity of the original impulse. No one who has studied the relation which the holy man bears to the race in India, can fail to understand the application of this law. There, the most startling negations will be accepted from a seer as the natural evidence of his own emancipation, and fall on society with

their full impetus of life, without for a moment disturbing that calm graduation of experience by which they were reached. Any Indian man or woman will worship at the feet of some inspired wayfarer who tells them that there can be no image of God, that the word itself is a limitation, and go straightway, as the natural sequence, to pour water on the head of the Siva-lingam. Unless we can grasp the secret of this inclusion of opposites, the mutual relations of Northern and Southern Buddhism must baffle us. For it is not possible to say that either is true, and the other false, but it is perfectly comprehensible that, as the narrower basis of Southern Buddhism, we have the echo of the great voice itself, crying alone in the wilderness, amongst those who know nothing of its whence or whither, while in the Northern school we listen to the Buddha in his true relativity, as the apex of the religious experience of his country. Northern Buddhism is thus like some great mountain ravine, through which *India* pours her intellectual torrents upon the world, and the contention that in Kashmir was made the most authoritative deposit of the doctrine, though it may or may not be true in the sense intended, has an inevitable accuracy of its own, deeper than the words imply.

Essentially, according to both interpretations, the message of Buddha was a message of the Freedom of the Soul, and those who heard were the emancipated children of the Ganges, already drinking to their full of the purity of the Absolute, in their Mahabharata and Upanishads. But beyond its philosophic grandeur, across all the flight of centuries and through the repetitions of both schools alike, we hear the divine voice tremble still with that passion of pity that stood forth in the midst of the most individualistic race in the world, and lifted the dumb beast to one level with man. In face of the spiritual feudalism whereby Caste makes a peasant in all his poverty one of the aristocrats of

humanity, we behold him in his infinite mercy, dreaming of the common people as one great heart, standing as the breaker of social bondage, and proclaiming equality and brotherhood to all. It was this second element, so akin to the feeling of Confucian China itself, that distinguished him from all previous developers of Vedic thought, and enabled his teaching to embrace all Asia, if not the whole of humankind.

Kapilavastu, the place of his birth, stands in Nepal, and was in his days even more Turanian than now. Scholars are wont sometimes to claim for him a Tartar origin, for the *Sakyas* may have been *Sakas*, or Scythians, and the frankly Mongolian type in which the earliest images represent him, as well as the golden or yellow colour of the skin described in the earliest sûtras, and remarkable presumptive evidence. The Taoists even go ridiculously further, and narrate in the *Roshi-Kakokio, the Book of the Conversion of the Barbarians by Laotse*, how Laotse himself, after his mysterious disappearance in Kwankokukwan, traveled to India, and there reincarnated himself as Gautama!

At any rate it is certain, whether or not there was Tartar blood in his veins, that he embodied the root-idea of that race, and in thereby universalising Indian idealism in its highest intensity, becomes the ocean in which the Ganges and the Hoang-Ho mingle their waters.

The monastic idea further differentiates him from all those other rishis and sannyasins who preached in the forests, but whose spirit of independence made of them stars, and not constellations. The existence of the Buddhist Church, mother of all churches as it is, demonstrates the dual trend of the Buddhist idea. For the organisation of the sannyasin is the thraldom of the emancipated, and yet the very soul of the Faith is its inquiry into the nature of freedom from that suffering which is known as life.

But, indeed, both freedom and bondage must have been modes of the great Sage. Perfection, in order to express itself, must necessarily fall back upon the contrast of opposites, and in announcing the quest of unity in the midst of variety, the assertion of the true individual at once in the universal and the particular, we have already postulated all the differentiations of the creed.

The Lion of Sakya in shaking his mane disperses the dust of Maya. He breaks through slavery to forms, and denies their very existence, as he directs the soul towards the Eternal Unity. This gives their basis to the atheistic formulæ of the later Southern school. At the same time, the joy and glory of union with the Absolute gives birth to an immense love of the beauty and significance of things, and draws the Northern Buddhists and their brother Hindus to paint the whole world with gods. His teaching was probably delivered in the Gatha, or some kindred transitional form of the original Sanskrit before Pali. But, as if to repudiate it with his own lips, he ordered his disciples to talk in the dialects of the people.

Such varying interpretations of a single truth, clothed thus with equal authority in widely different garbs, led inevitably to schismatic disputes. At first these were mainly concerned with the discipline or rule, which was the most important act of the great spiritual Deedsman, but later they involved such discussion of philosophic standpoints as to divide Buddhism into countless sects.

The original disruption seems to have occurred between those who represented the highest culture of that Indian thought which was a development of the Upanishads, and the acceptors of the popular interpretation of the new doctrine and discipline.

The *first stage of Buddhism*, immediately after the Nirvana— which we may consider to have taken place about the middle of

the sixth century B.C.—is concerned with the ascendancy of the primary group and the fact that its leaders the early patriarchs of the Church, taught a system of positive idealism, while their opponents were engaged mainly on details of the monastic rule, and in discussions upon the real and the unreal, which led for the most part to negative conclusions.

Asoka—the great emperor who united India, and made the influence of his empire felt from Ceylon to the limits of Syria and Egypt, deliberately recognising Buddhism as its unifying force—gave the weight of his personal influence to those thinkers who must have been closely allied to the Northern school, though with Asiatic toleration he patronised their opponents also, and did not fail to countenance the Brahminical religion itself. His son Mahindra converted Ceylon to Buddhism, laying the foundations there of the Northern school, which still survived in the seventh century, when Gensho (Hieuntsang) visited India, till the reflux from Siam, a few centuries later, of the Southern doctrine, of which it remains the present stronghold.

Northern India and Kashmir, where immediate disciples preached the faith, formed the busiest seat of Buddhist activity. It was in Kashmir, in the first century after Christ, that Kanishka—that King of the Gettaes who extended his power from Central Asia to the Punjaub, and left his footprints at Mathura, near Agra—called a great Buddhist council, whose influence spread Buddhism farther into Central Asia. But all this was only enforcing the work begun by Asoka, the great descendant of Chandra Gupta (fourth century B.C.).

Nagarjuna was an Indian monk, whose name is well known in China and Japan. In the second century of the Christian era, he followed in the wake of previous teachers, known as Asvaghosha and Vasumitra, the latter of whom had acted as

president of Kanishka's council. Nagarjuna gave ultimate form to this, the first school of Buddhism, by means of his eight negations and the elucidation of the middle path that lies between two opposites, as well as by his recognition of the infinite self, the great soul and light which pervades the All. This is a doctrine which the Buddha of the Pali texts (the Southern school) does not deny, though he there preaches the non-existence of the finite self. The fact that the memory of Nagarjuna connects itself with Orissa and Southern India, and that his immediate successor, Deva, came from Ceylon, shows the wide range within which the influence of this first school worked.

In India the art of this early Buddhism was a natural growth out of that of the Epic age that went before. For it is idle to deny the existence of pre-Buddhistic Indian art, ascribing its sudden birth to the influence of the Greeks, as European archæologists are wont to do. The Mahabharata and Ramayana contain frequent and essential allusions to storeyed towers, galleries of pictures, and castes of painters, not to speak of the golden statue of a heroine, and the magnificence of personal adornment. Indeed, it is difficult to imagine that those centuries in which the wandering minstrels sang the ballads that were later to become the epics, were devoid of image-worship, for descriptive literature, concerning the forms of gods, means correlative attempts at plastic actualisation. This idea finds corroboration in the sculptures of Asoka's rails, where we find images of Indras and Devas worshipping the bo-tree. These things point to the early use of clay, paste, and other impermanent materials, as in ancient China. We find a trace of this custom again as late as the Gupta period, in the habit of covering the stone basis of the statue with paste or plaster. Probably the rails of Asoka were originally so covered. There is here no trace of the influence of the Greeks,

and if it be necessary to establish a relation with any foreign school, it must surely be with that old Asiatic art whose traces are to be found amongst Mesopotamians, Chinese, and Persians, the last of whom are but a branch race of the Indian.

The lofty iron pillar of Asoka at Delhi-strange marvel of casting, which Europe, with all her scientific mechanism, cannot imitate to-day, like the twelve colossal iron images of Asoka's contemporary, the Shin Emperor of China, points us to ages of skilled workmanship and vast resources. Too little effort is spent in reconstructing the idea of that great splendour and activity which must have existed, in order to leave such wreckage as it has to a later age. It may be that the desolate wastes of Kurukshetra, and the wailing weeds of Rajagriha, still cherish the memory of an ancient glory, which they cower down to cover from alien eyes.

Images of the Buddha himself, though absent from the early stupas, and now undistinguishable by us among the existing specimens of this early period, may probably have been the first work of his disciples, who soon learned to clothe his memory with the Jataka legends, and to beautify his ideal personality.

In the post-Asokan period in India we find Buddhist art-activity working out of the confinement of its primitive type into freer forms and a wider range of subjects, yet remaining always a legitimate development of the national school, whether seen in the rock-temples of Orissa and the rails of Sanchi, or in the elegant delineations of Amaravati, the culmination of the art of this school of the third century.

The remains of Mathura and Gandhara fall into the general movement, for Kanishka and the Gettaes, in imposing their Mongolian traits on Indian art, could but bring it within

the shadow of that common ancient style in which a deeper and better-informed study of the works of Gandhara itself will reveal a greater prominence of Chinese than of the so-called Greek characteristics. The Bactrian kingdom in Afghanistan was never more than a small colony in the midst of a great Tartar population, and was already lost in the late centuries before the Christian era. The Alexandrian invasion means rather the extension of Persian influence than of Hellenic culture.

The second stage of Buddhist activity—on whose Sino-Japanese development we shall have occasion to touch in the Nara period-begins in the fourth century under the Gupta dynasty, which was able through the preceding Andras to amalgamate the Dravidian culture of the South and that of the Cholas.

We now find Asangha and Vasubandhu inaugurating the school of objective research, a movement whose poetic impulse reaches extraordinary scientific expression. It must be understood that Buddhism, owing to its special definition of Maya, is a religious idea remarkably retentive of scientific effort, and we have in this period a forcible demonstration of the fact. This was the age of that great intellectual expansion when Kalidasa sang, and astronomy scaled its heights under Varahamihira, lasting till the seventh century, with Nalanda as its centre of learning.

The art of this second Buddhist epoch is best seen in the wall-paintings of Ajanta, and in the sculptures of the Ellora caves, now the few remaining specimens of a great Indian art, which doubtless, thanks to innumerable travellers, gave its inspiration to the Tâng art of China.

The third phase of Buddhism, the era of concrete idealism, begins with the seventh century to sound the dominant note of the faith, spreading its influence to Thibet, there to become,

on the one hand, Lamaism, and on the other Tantrikism, and reaching China and Japan as the Esoteric doctrine, to create the art of the Heian period.

It was now that the idea of the Southern school of Buddhism, which had always been working side by side with its companion movement, penetrated Burmah and Siam., and, returning upon Ceylon, absorbed the remnant of the Northern adherents in that island, thus creating a new stratum of Indo-Chinese art, very different in style from that of the North.

Hinduism—that form into which the Indian national consciousness had been striving to resolve Buddhism ever since its appearance as a creed—is now recognised once more as the inclusive form of the nation's life. The great Vedantic revival of Sankaracharya is the assimilation of Buddhism, and its emergence in a new dynamic form. And now, in spite of the separation of ages, Japan is drawn closer than ever to the motherland of thought.

Notes

The spiritual feudalism whereby.—This is an allusion to the ideal of Brahminhood, which is complete culture rooted and practised in an extreme simplicity of life. The Brahmin villager may be not only a scholar in the European university sense of the term, but also a man of emancipated intellect and character. And yet it will be his pride to remain always the same frugal villager. Much more does this standard hold good of the sannyasin, who is expected to worship poverty as did S. Francis of Assisi. It may be said that in India, amongst both these classes, many men are to be found of whom the statement made in the text is by no means exaggerated.

Mahabharata.—The epic of "Great India," which sings of the war between the Kurus and Pandavas. This war must have occurred some ten or twelve centuries before Christ, and its history is still the heroic feature in the education of Indian boys of the upper classes. It contains the Bhagavad Gita, as one of its episodes, and it may be said of this short gospel that it embodies all the essential features of Northern Buddhism.

The Upanishads.—These were written at least as early as from 2000 to 700 B.C. They are supplementary to the Vedas, and form the great religious classics of the Hindu people. Their subject-matter is the realisation of the super-personal existence. For depth and grandeur they are without rivals in the literature of the world.

The Ramayana.—The second of the great Indian epics, dealing with the heroic love of Rama and Sita.

Kurukshetra, or Field of the Kurus.—The great plain in the neighbourhood of Delhi, where the eighteen days' battle, recorded in the Mahabharata, took place. It was here that the Gita was spoken. It is now only a place of pilgrimage.

Rajagriha.—The ancient capital of Magadha, before it was removed to Patna, within the province now known as Behar, India.

Nalanda.—The great monastery and university of Buddhist learning, in the vicinity of Rajagriha.

The Asuka Period

550 to 700 A.D.

The first Buddhist period in Japan begins with the formal introduction of Buddhism from Corea in 552. It is called the Asuka period because the capital was in that province, until its final removal to Nara in 710 A.D. And it signifies the influence upon Japanese development of that original stream of abstract idealism which, through the Asoka-Kanishka consolidation, brought the waters of the new faith to China.

It is, of course, possible that the missionaries of Asoka reached the Celestial Empire in the reign of the first Shin tyrant. But if so, they left little trace. The historical records which we can authenticate begin about the year 59 A.D., when an ambassador of the Gettaes, then probably under Kanishka, gave to the Chinese scholar Saian, certain translations of a Buddhist scripture. In 64 A.D. Meitei, a Hâng Emperor, dreamt of a huge golden god, and on waking asked his courtiers for the meaning of his dream. It was this Saian, now a scholar of great repute, who proved able to explain about the Buddhism of the West, and he was sent next year, with eighteen followers, to the Gettaes, returning in 67 A.D., with Buddhist images and two monks, Matanga and

Horan, claiming to be from Central India. It is told of them that they were lodged in the palace reserved for alien subjects in Loyang, the capital—for China, during the Hâng period, claimed sovereignty over the whole world. This palace was subsequently turned into a monastery, called the "Temple of the White Horse," and its site is still to be seen, in the suburbs of that shrunken city of Loyang, which is so rich in ancient ruins. It is recorded that Matanga painted on the walls of the palace a stupa which was surrounded by one thousand chariots and horsemen, and suggests to us the decorated stupas and rails of Sanchi and Amaravati, which were, of course, the fashion of this age. Of the images they brought, little is known.

The next monk, Ansei, comes from Arsaie, the land of the Parthians. He is followed by others from the neighbouring country of the Gettaes, and an embassy is recorded to have come from India by way of Cochin China, in 159 A.D. These teachers translated those Buddhist scriptures which belonged to the first phase of the Northern school (positive idealism), and towards the end of the third century the translation of the Amida-Sutra was accomplished.

The word *amitabha* means immeasurable light, and represents the idea of the impersonal divine—that vision of the grand Eternal known as Brahman in the Indian Upanishads—in contradistinction to the personal divine as manifested in Sakya Muni. The recognition of this fundamental difference distinguishes the Northern from the Southern school of Buddhists, by the latter of whom Nirvana, or freedom from the world of relativity, is sought as the final goal of attainment, while by the former it is regarded as the beginning of a new glory. We owe the first elucidation of the idea extant to Asvaghosha; it is our

common heritage from that early Indian philosophy of which Buddhism is a development.

The tree of Buddhism was taking gradual root in China, when the over-running of the North by the Hunnish races of the border, who established what is called the Northern dynasty, gave a great and sudden impetus to its growth. For these tribes already, amongst their wild steppes, were adherents of the faith, though in a form coloured with the superstitions and prejudices natural to their barbaric state, and very different from that version which, by its philosophic soundness and affinity to the ideas of the Conversationalists, had appealed to the civilised world of the Chinese Southern, or native, dynasty.

Buttocho, a teacher who is said to have been an Indian monk, wielded a great influence amongst the fierce and turbulent Hun soldiery. He was said to be possessed of supernatural powers, and as such was held in awe by the people, who are said never to have spat in his direction. He was able, by his personal influence, to stop much cruelty and bloodshed under the Northern Cho dynasty. His pupil Doan went southward, and in collaboration with Yéon, assisted in the promulgation of the faith in Amida, or the quest of salvation by contemplation of, and prayer to, the ideal Buddha in the Western heavens. Kumarajiva, son of a Gettae father and an Indian mother, and supposed to have been a native of Korsar, was so renowned in his day, that a Northern emperor despatched an army to bring him as a teacher to China, where he arrived in 401 A.D. He devoted himself to the innumerable translations of Buddhist scriptures and laid the foundation of that Buddhistic scholarship which culminates in Chiki of the Tendai Mountains, at the end of the sixth century.

This history of the long succession of important teachers, implying the constant flow of a stream of wandering thinkers

from India to China throughout the period, raises the inter-
esting question of the means of intercourse. It appears that
besides the sea-route from the Bengal coast by Ceylon to the
mouth of the Yang-tse-Kiang, there were two great landways,
which both began at Tonko in China, at the mouth of the Gobi
Desert, divided before reaching the Oxus, into the northern and
southern passes of Tensan, and so on to the Indus. Embassies
probably went by sea.

We have here the clue to a great era, when North-Western
India was a central point between two empires, and through a
living world of communication, travellers, pilgrims, and traders
carried the common culture back and forth. It is probable, too,
that in the Mussulman conquest of India, forcing this immense
trade into quiescence at both ends, we have the secret of the
process that has so robbed the Orient of her prestige, leading
the Mediterranean and Baltic peoples to regard the whole East
as but so many victims of an "arrested development."

The artistic attempts of the period are numerous, and some
are on a gigantic scale. But the chief idea of a nation that would
admit Buddhist images to the Taoist pantheon seems to have
been the clothing of Indian religion in the Chinese garb of the
Hâng period of art, and this was done much in the way that
early Christian temples and images were constructed, in the
style of Roman architecture and sculpture.

With regard to building, as observed before, Chinese palaces
were changed at once into Buddhist temples in an impulse of
renunciation, only such alterations being made as would meet
the new needs. The stupa, through its evolution of the tee, had,
so early as the time of Kanishka, attained several stories, and
when translated into Chinese forms, under the conditions of
wooden architecture, became the wooden pagoda, as known to

this day in Japan. Of these, two kinds exist, one the rectangular and the other the circular type, the latter still retaining the form of the original dome.

The first pagoda built in wood by Rioken, in 217 A.D., must have been modelled upon the many-storeyed towers that existed under the Hang dynasty, with the modification of the disked spires, originally a canopy or umbrella, the emblem of sovereignty, whose number denoted the grade of spiritual rank, three indicating a saint, and nine the supreme Buddha. Wooden pagodas, built in the beginning of the sixth century, of which fortunately some descriptions remain, seem more and more to have followed the Indian method of ornamentation, for regarding them we read of the great vase at the top, in striking reminder of the description by Gensho (Hiouen-Tsang) of the ornaments of the Buddha Gaya Stupa, built in the same century by Amara Singh, one of the so-called "Nine Gems of Learning" of the court of Vikramaditya.

Sculpture seems to have followed a parallel course. The Indian type looked at first outlandish to the Chinese mind, and sculptors like Taiando, in the fourth century, devoted themselves to evolving a new type, by constant changing of its proportions. Taiando was so eager to have frank criticism that he hung a curtain at the back of a statue of his, and lay behind it three years to hear the remark of the public. That there was a distinct school of Chinese sculpture is manifest from the records of the pilgrim Hoken (Fahian), who describes the statues of a certain border country as quite Chinese in type, in contrast with the Indian type of other places, and ascribes the origin of the style to the influence of a Chinese general, Roko, who had occupied the territory, though we should consider this to be no more than an enforcing of the style of sculpture evolved by the Gettae in

the Punjaub, whose traces are seen even in Mathura. Indeed, the existing specimens of this period follow in the main, as far as we know, the Hang style, in features, drapery, and decoration.

The most typical examples that we can recall are the rock-cut images of Riumonsan, near Loyang. They form part of the cave-temples which the Empress Dowager Ko constructed in 516 A.D. This place is still very impressive in its ruin, as it is not only representative of the period, but is a perfect museum in itself, containing more than ten thousand Buddhist images, some of the Tâng and some as late as Sung, with authentic dates attached to them, which are thus of immense importance. Grottoes follow upon grottoes, all with pointed domes; the sculptures are in low and in high relief, and the main figures are cut out to be almost free of the rock.

A Chinese poet who visited the place has left upon a rock the inscription, "The very stones here are grown aged, and have thus attained to Buddhahood." The place in itself is beautiful, for below the precipice on which the Buddhas are cut runs the mad torrent of Isui, and on the opposite bank is a little temple called Kosanji. The site of the house of Hakurakuten, our beloved Tâng poet, is still to be seen here.

In the Asuka period, when Buddhism first reached Japan, the Soga family held the most prominent place in the state, as the Fujiwaras and Minamotos did in succeeding ages. The Sogas remained a powerful factor in the empire from the days of their founder, Takanouchi Sukune, who was the adviser and prime minister of the empress Zhingo, in her famous conquest of Korea. He may be seen in later pictures painted as a venerable bearded man, holding the infant emperor in his arms. From this time onwards his family were hereditary ministers of foreign affairs, and the traditions of their blood naturally

led them to love and reverence foreign culture and institutions, whereas other native princes tended to the strict conservation of national customs. For the responsibility of government usually remained with the powerful aristocracy who surrounded the throne, and carried out mandates with the sanction of the imperial name. This is the survival of that "Assembly of the Gods" who were held to have given counsel to the supreme Godhead in Takamagahara.

The civil commotion attending the establishment of Buddhism in Japan becomes thus a matter of family jealousies between the Sogas and the Mononobes, hereditary commanders-in-chief of the territorial army, supported on their side by the Nakotomis, the ancestors of the Fujiwaras, who, as head priests, or more properly, custodians, of the ancestral rites, clung naturally to the ancient notions, in defiance of the new religion. The Otomos, who were hereditary admirals in the Japanese navy, cruising along their stations on the Korean coast, leaned to the side of the Sogas, at least in the fact that they stood neutral in the dispute. These disastrous struggles for power, which ended with the supremacy of the Sogas, were attended by the never-to-be-forgotten crime of impericide, and several dethronements—a matter of grave chagrin to the Japanese of the present day—but were otherwise not unlike the state of affairs at the recent Meiji restoration, when progressives and conservatives fought out their differences of aims and opinions, though in a kindlier spirit.

The imperial power, curtailed by oligarchic preponderance in the Soga period, was unable to veto the claims on either side. Thus when the Korean king, Meirei, in the thirteenth year of the reign of Emperor Kimmei (552 A.D.), sent ambassadors bearing a bronze-gilt statue of Sakya-Muni, with hangings and canopies and sundry Buddhist scriptures—addressing a memorial, saying,

"Your vassal Mei, King of Kudara, respectfully sends this vassal of your vassal Rurishitike, to bear the accompanying image into your empire, that the teaching may flow and spread towards all your boundaries, according to the Buddha's command, who commanded that His law should flow Eastward,"—the Emperor was, of course, glad to receive the tribute, but was obliged to hesitate about accepting it. He therefore put the question to his ministers, amongst whom Iname of Soga proposed that it should be worshipped with due rites, whereas Okoshi of Mononobe, the father of Moria—name dreaded of Buddhists!—and Kamako of Nakatomi, proposed that they should reject it with its embassy of escort.

The Emperor decided the matter by entrusting the statue to Iname, in a spirit of tolerance, and it was placed in his villa at Mukobara for a time. But the pestilence and famine which raged in the ensuing year gave a pretext to the enemies of the Sogas, who promptly declared that such disasters came from worshipping alien gods. Thus they got permission to burn its accessories and throw the statue into the neighbouring lake.

It appears, however, that before their formal adoption by the court, Buddhist monks and images were already known in the country. Shibatatsu, of the Rio dynasty in Southern China, a devout believer, and grandfather of the celebrated sculptor, Tori, who is the most prominent figure in the arts of this period, had migrated to Japan thirty-one years before this event, and his daughter became the first nun who worshipped the Buddhist images. The Korean priests, Donyei and Doshin, arrived in 554 A.D. Chiso, a Southern Chinese, is also said to have brought over images and sculptures ten years later, and in spite of conservative persecution, the cult gained ground daily. The Korean Kings of Kudara and Shiragi vied with each other in Buddhist

presents, and Wumako, the son of Iname, who succeeded his
father as prime minister, erected Buddhist temples in 584. The
year 573 is remarkable for the birth of Prince Wumayado, com-
monly known as Shotoku-Taishi, the Saint amongst Princes,
who becomes the great personification of this first Buddhist
illumination. He as regent of his aunt, the Empress Suiko, wrote
the seventeen articles of the Japanese constitution. This docu-
ment proclaims the duty of devotion to the Emperor, inculcates
Confucian ethics, and lays its stress on the greatness of that
Indian ideal which is to pervade them all—thus epitomising
the national life of Japan for thirteen centuries to follow. His
commentaries on the Buddhist sûtras not only evince remark-
able scholarship in Chinese, but by their clear setting out of the
principles of Nagarjuna (second century A.D.) prove a masterly
insight and inspiration. The book was a marvel to Koreans and
Chinese. The death of Prince Wumayado in 621 A.D., was the
signal for universal despair, people beating their breasts in the
sorrow of a night robbed of its moon. He is still worshipped as
the Patron of the Arts by all craftsmen and artisans, and espe-
cially at Tennoji in Osaka.

It was in 588 that the disputes between the rival families had come
to a head, when each had sought to place on the throne the upholder
of its own creed, ending in the defeat of Moria and Nakatomi,
and the subsequent assassination of the succeeding Emperor, who
chose to object to the dictation of Wumako. Wumako had then
placed his own grand-niece Suiko on the throne, she being also
the granddaughter of the Emperor. Her long reign, from 593 to 628
A.D., with Prince Wumayado as regent, forms the culmination of
the first Buddhist movement, which is sometimes called from her,
the Suiko epoch. Her capital was in the province of Asuka about
twelve miles to the south of Nara, where the emperors had resided

ever since the days of Kimmei. Unfortunately, no specimens remain
in Asuka itself, and since the transfer of the capital to Nara, the
whole place has fallen into decay. A few temples here and there,
and some marble foundations scattered amongst the mulberry trees,
alone mark its past importance.

The one exception to this is the colossal bronze of Ankoin,
on the site of the Asuka temple, which history reports to have
been cast in the fifteenth year of Suiko's reign. Its proportions
were too large to allow of its entering the door of that great
temple, and this taxed the ingenuity of the sculptor Tori, who
was rewarded for his toils with a high court rank and a grant of
extensive estates in the provinces. The statue has suffered from
fire and other casualties, having been once at least on the point
of total destruction. The repairs, too, are of that unfortunate
early Tokugawa period, which so obliterates the main points of
the original that only by arms and sleeves, forehead and ears,
can we determine the actual type of this celebrated statue.

Luckily for us, the Horinji temple near Nara was built close
to the residence of Prince Wumayado, and remains rich in the
architectural and other art specimens of this period. In the
Kondo, or Golden Hall, is still to be seen the Sakya trinity, cast
by Tori, under the command of the prince, bearing the date of
600, and another trinity of Yakshi, bearing the date of 625, the
height of each, including the halo, being about seven feet. In
these statues we find the same Hâng type that we noticed in the
rock-cut temples of Riumonsan more than a century earlier.

A Kwannon (Avalokiteswara), ten feet in height, made of
wood and lacquer paste, and purporting to have been presented
by one of the Korean kings, stands in the same hall. It may
have been made in that country, or by some of the numerous
Korean artisans who flocked to Japan at that time. Another

Kwannon, which has been unrevealed to public gaze for centuries, and is preserved in a remarkable condition, is the Kwannon of Yumedono in the same temple. From these two we can judge of that idealised purity of expression which characterises the Hâng type as it appears in Buddhist art. The proportions are not exactly fine—hands and feet are disproportionate in size, and the features have almost the rigid calm of Egyptian sculpture. Yet, with all these drawbacks, we find in these works a spirit of intense refinement and purity, such as only great religious feeling could have produced. For divinity, in this early phase of national realisation, seemed like an abstract ideal, unapproachable and mysterious, and even its distance from the naturalesque gives to art an awful charm.

But it seemed that the Japanese mind, with its innate love of beauty and concreteness, was not to be satisfied with abstract types presented to it by Chinese and Korean masters. Contemporary with these, therefore, we find a new movement in sculpture, which aims at softening rigid outlines and bettering the proportions. The typical example is found in the wooden Kwannon of Chiuguji, a nunnery, founded by the daughters of the prince, and attached to the same Horinji temple. This statue, which is believed to be of about the close of the Asuka era, is wonderful for its tenderness of expression and beautiful proportions, though it adheres strictly to the Hâng type of the period. Besides the Buddhas and Bodhisattvas there is also the type of Devarajas—known as the "Guardians of Law," sustaining the four corners of the universe—which is preserved to us in the same temple under the name of the "Four Guardian Kings." These last statues are signed by Yamaghuchi, Oguchi, Kusushi, and Toriko, of whom the first is mentioned elsewhere as a celebrated artist in the middle of the seventh century. One

notable point about these kings is that the metal work which decorates the headpiece and parts of the armour still preserves the old Hang patterns found in early dolmens.

The only example now extant of the paintings of this period consists of the lacquer decorations of a shrine belonging to the Empress Suiko herself. This is an excellent specimen of the Hâng style.

An embroidery, representing the Kingdom of Infinite Bliss, called Tenju-koku,—into which paradise the spirit of the Prince Wumayado was felt to have passed, his surviving princesses, with their damsels, working this tapestry to his memory from a design by one of the Korean artists—still remains in Chiuguji, and corroborates that interpretation of the colouring and drawing of the period, which we gather from the Suiko shrine.

Of the architectural remains the shrine itself is a typical example, and the Golden Hall, Kondo, is, broadly speaking, true to the type, in spite of having been restored a century later. The pagodas of the neighbouring temples, Horinji and Hokiji, are also specimens of the same style.

Notes

The dates which divide Japanese history having been somewhat generalised for the purposes of the present sketch, it is thought well to supply the following brief summary in more accurate form for use in reference.

The Asuka Period.—Lasted from the introduction of Buddhism in 552 to the accession of the Emperor Tenji, 667 A.D. This era in Japan is much influenced by the great vigour of Buddhism in China, under the Tâng dynasty.

The Fujiwara Period.—From the accession of the Emperor Seiwa in 898, to the fall of the Taira family in 1186 A.D. This age is characterised by a purely national development of Buddhist art and philosophy, under the Fujiwara aristocracy.

The Kamakura Period, 1186 *to* 1394 A.D.—From the rise of the Minamoto Shogunate in Kamakura, to that of the Ashikaga Shogunate.

The Ashikaga Period, 1394 *to* 1587 A.D.—So called from a place in the province Musashi, which had been the original residence of that branch of the Minamoto family who held the Shogunate during this time.

The Toyotomi and Early Tokugawa Periods.—From the supremacy of Hideyoshin in 1587 to the accession of the Shogun Yoshimune, 1711 A.D.

The Later Tokugawa Period.—From the accession of the Shogun Yoshimune, 1711, to the fall of the Shogunate, 1867 A.D. This era sees the rise of the middle classes, and, assisted by European influence, the advent of the realistic school in art.

The Meiji Period.—From the accession of the reigning Emperor in 1867 to the present day.

Kwannon.—This word is an abbreviation of Kwangion or Kwangizai, meaning Avalokiteswara—the Lord who witnesseth. The name denotes one of the great Bodhi-Sattvas, who refuse Nirvana until the salvation of the universe is accomplished. Kwannon was originally conceived as a youth, something like the Christian idea of the angels. Afterwards the form becomes pre-eminently that of woman and mother. This emanation is self-manifested in every cry of sorrow, in every sight of pity. Kwannon has thirty-three forms, representing all grades of

existence. "Wherever a gnat cries, there am I," may be taken as the keynote of the Lotus-Sûtra. He (or She) represents that satisfaction which comes before renunciation. He is never, therefore, the giver of Nirvana, but only of the step before salvation. Not the Buddha, but the Bodhi-Sattva. He is known in Indian Buddhism as Padmapani, the Lotus-Holder, in contrast to Vajrapani, holder of the thunderbolt.

The Nara Period

700 to 800 A.D.

A new era was to be born. The whole of Asiatic thought was surging on, past that distant vision of the Indian Abstract-Universal which Buddhism had made possible, to recognise its supreme self-revelation in the Cosmos itself. The vulgarisation of this impulse was to betray itself in the succeeding period, when the tendency to a sordid and hardened symbolism would take the place of the direct perception of the beautiful. But for the moment Spirit was seeking union with Matter, and the joy of the first embrace was to ring from Ujjain to Choan and Nara through the songs of Kalidasa, of Ritaihaku, and of Hitomaru. Three great political figures inaugurated this age of liberalism and grandeur. In India the sixth century saw Vikramaditya overthrow the Hunas and awaken in the North that sense of nationality which had slept ever since the days of Asoka. A century later Rissemin (Taiso), the first Tâng emperor, succeeded in unifying China after her three centuries of disintegration under the Six Dynasties, and founding an empire next in extent to that of Genghis Khan. And his contemporary, the Emperor Tenjitenno, broke the hereditary power of the nobles

and consolidated Japan under the immediate shadow of the imperial throne.

In India, too, there is a lull in those discussions of the Abstract and Immutable, which began with the Upanishads and culminated with Nagarjuna in the second century; and we catch a glimpse of the great river of science which never ceases to flow in that country. For India has carried and scattered the data of intellectual progress for the whole world, ever since the pre-Buddhistic period when she produced the Sankhya philosophy and the atomic theory; the fifth century, when her mathematics and astronomy find their blossom in Aryabhatta; the seventh, when Brahmagupta uses his highly-developed algebra and makes astronomical observations; the twelfth, brilliant with the glory of Bhaskaracharya and his famous daughter, down to the nineteenth and twentieth centuries themselves, with Ham Chandra the mathematician, and Jagadis Chunder Bose the physicist.[1]

In the era which we are considering, beginning with Asangha and Vasubandhu, the whole energy of Buddhism is thrown upon this scientific research into the world of the senses and of phenomena, and one of the first outcomes is an elaborate psychology treating of the evolution of the finite soul in its fifty-two stages of growth and final liberation in the infinite. That the whole universe is manifest in every atom; that each variety, therefore, is of equal authenticity; that there is no truth unrelated to the unity of things; this is the faith that liberates the Indian mind in science, and which even in the present day is so potent to free it from the hard shell of specialism that one of her sons has been enabled, with the severest scientific demonstration, to bridge over the supposed chasm between the organic and inorganic

[1] Author of "Response in the Living and Non-Living." Longmans, 1902.

worlds. Such a faith, in its early energy and enthusiasm, was the natural incentive to that great scientific age which was to produce astronomers like Aryabhatta, discovering the revolution of the earth on its own axis, and his not less illustrious successor, Varamihira; which brought Hindu medicine to its height, perhaps under Susruta, and which finally gave to Arabia the knowledge with which she was later to fructify Europe.

It was also an age of poetry, distinguished by the names of Kalidasa, Banabhatta, and the Jain Ravikirti, creating that richness of imagery and allusion that was afterwards to clothe Hinduism with puranic lore.

Buddhist art now assumes the aspect of calm which always rises out of the blending of the spirit with matter, in a repose where neither attempts to overwhelm the other, and thus becomes akin to the classic ideal of the Greeks, whose pantheism led them to a similar expression. Sculpture is, *par excellence*, the form best adapted to this conception, and the stone Buddhas of the Tin Tal in Ellora, though deprived of the plaster mouldings with which they were originally covered, are beautiful, with a self-contained grandeur and harmony of proportion. In them we find the sources of inspiration of the Tâng and Nara sculptures.

The China of the Tâng dynasty (618 to 907 A.D.), enriched by the fresh Tartar blood of the preceding Six Dynasties, bursts forth now into a new life, which amalgamates the Hoang-Ho and the Yang-tse. Communication with India becomes more facilitated by the extension of the empire on the Pamirs, and the number of pilgrims to the land of Buddha, as well as the influx of Indians into China, grows greater every day. Gensho (Hiouen-Tsang) and Gijo (Iching), though noted for their records, are only two out of innumerable instances of the intercourse between the countries. The newly-opened route through Thibet, which

had been conquered by Taiso, added a fourth line of communication to the former routes by Tensan and the sea. There were at one time in Loyang itself, to impress their national religion and art on Chinese soil, more than three thousand Indian monks and ten thousand Indian families; their great influence may be judged from their having given phonetic values to the Chinese ideographs, a movement which, in the eighth century, resulted in the creation of the present Japanese alphabet.

The memory of the wonderful enthusiasm that was born of this continental fusion of the moment survives to this day in Japan, in a quaint folk-story of three travellers meeting in Loyang. One came from India, one from Japan, and one from the Celestial soil itself. "But we meet here," said the last, "as if to make a fan, of which China represents the paper, you from India the radiating sticks, and our Japanese guest the small but necessary pivot!"

This was an age of toleration, as may always be expected wherever there is a permeation of the Indian spirit, when in China Confucians, Taoists, and Buddhists were equally honoured, when the Nestorian fathers were allowed to spread their cult, as the Choan tablets attest, and when Zoroastrians were permitted to establish their fire-worship in the important cities of the empire, leaving traces of Byzantine and Persian influence in Chinese decorative art—in the same temper which in India made Yasovardhan and the Siladitya of Kanauj honour Brahmins, Jains, and Buddhists equally. Thus the three streams of Chinese thought flow side by side, and Toshimi, Ritaihaku, and Omakitsu, who represent the poetic ideals of these three rival conceptions, express also, none the less, the grand harmony of the Tang period, whose assimilative idea is so early expressed through Bunchusi, the teacher of Gicho, chief adviser of Taiso himself. This harmony foreshadows the Neo-Confucianism of the succeeding Sung

dynasty in China (960 to 1280 A.D.), when Confucians, Taoists, and Buddhists together became a single national completeness.

Buddhism, the predominating impulse of the period, was, of course, that of the second Indian (monastic) phase. Gensho (Hiouen-Tsang) was a pupil of Mitrasena, a disciple of Vasubandhu, and through his great translations and commentaries he, on his return from India, inaugurated the new school known as the Hosso sect, of which the idea seems to have been at work even before his time. Kenshu, assisted by Gissananda of Central, and Bodhi-ruchi of Southern India, further enforced the same movement in the beginning of the eighth century, and established the Kegon sect, which aims at complete fusion of mind and matter. The intellectual effort of this period being so closely akin to that of modern science, art becomes largely a reaching forth towards a visualisation of the vastness of the universe, resting and centring itself upon the Buddha. It therefore assumes colossal dimensions, and the Buddha images become the immense Roshana (Vairochana) Buddhas. The Roshana Buddha is the Buddha of Law in contrast to the Buddha of Mercy, which is Amida, and the Buddha of Adaptation, which is Sakya-Muni himself.

As the best existing specimen of the time we shall refer to the gigantic Roshana of the Riumonsan, which was mentioned before. This statue, similar in type to the Buddhas of Ellora, is more than sixty feet high, and towers in great magnificence against the rocky precipice of the wonderful hillside of Riumonsan, with a foaming torrent at its foot.

Another Roshana Buddha of stone is to be seen on the Yangtse below Tobaro, near Kakoken. It is cut out of a single rock, a mountain in itself, and its size may be imagined from the fact that a large pine tree has grown in such a way as to take the place, without any apparent incongruity, of one of the spiral lines of the head-dress. It

is sitting on a lotus daïs in the usual style, and as it is cut out of red sand-stone, most of the features have been effaced, though even in its original state it must have been difficult to study, on account of the rushing stream of the Yang-tse at its base.

In Japan, the Emperor Tenji, who crushed the Soga family, consolidated the personal government of the emperors, beginning a new régime in 645, which lasted till the Fujiwaras, descendants of his prime minister, Kamatari, again veiled the throne by their aristocratic power. The provincial government was managed by appointed governors, instead of by hereditary princes, as in former days; a system of laws, modelled on those of the Tâng court, was compiled; and justice was administered by a specially-appointed body of judges. The country was opened up with a new energy. Roads were built; the means of transportation were regulated on a sounder basis, relays of horses being established on the routes; and a general reform of interior administration was effected, though perhaps at the sacrifice of foreign supremacy. Japan was growing in prosperity, and it was found necessary in 710 to found on the wider plains of the Yamato a new capital, now known as the town of Nara. This city became the great Buddhist centre, and the strength of its hierarchy was enough later to threaten the throne and the nobility.

Dosho, a Japanese monk, had become a personal pupil of Gensho (Hiouen-Tsang) in Choan, and returned again to Japan in the year 677. It was through him, and again through Giogi, in the middle of the eighth century, that we were able to introduce the Hosso and Kegon sects, and thus incorporate the ideas, and begin to share in the general development of the new form of the Northern movement.

It is easy to understand, therefore, that the art of the Nara period is reflected from that of the early Tâng dynasty, and has

even a direct connection with its prototype in India; for many Indian artists are recorded as having crossed over at this time to our shores. Gumporik, a follower of Kanshin, a great Chinese monk who founded the Vinaya sect in this period, was a sculptor presumably from Ceylon, and the similarity of his works to those of Anarajapura shows the contemporary predominance of the full Gupta type all over India. One would hope, however, that it is not mere national pride which finds in the Japanese rendering of the same themes, not only the abstract beauty of the Indian model, with the strength of the Tang, but also an added delicacy and completeness that makes the art of Nara the highest formal expression of the second Asiatic thought.

The Nara period thus inaugurated is remarkable for its wealth of sculpture, which begins with the bronze trinity of Amida in Yakushiji and is followed by the Yakshi trinity of the same temple thirty years later, undoubtedly the finest existing specimen of this art. In connection with these must also be mentioned the Kwannon of Toindo and the Sakya of Kanimanji.

The era of large bronzes culminates, however, in the colossal Roshana Buddha of Nara, which is the largest statue of cast bronze in the whole world. This image is seen at a disadvantage to-day, since it has suffered twice from fire, once in the Taira epoch in 1180, when the head and hand were destroyed—though the first repairs in the Kamakura epoch, effected by the able sculptor Kaikei, seem, judging from the remaining designs, to have preserved the original proportions well—and the next during the civil wars in the sixteenth century. The present head and hand date from the restoration during the Tokugawa period two hundred years ago, when sculpture was at its lowest ebb and the artist had lost all idea of the type and proportions of the original period. But any one looking at it with these facts in mind cannot fail to see the

great beauty and boldness of conception of this monumental work, in spite of the cramped space which the present building covering it allows to the pilgrim's view. The original building was forty-five feet higher and eighty feet longer than the present.

We owe the idea of the statue to the Emperor Shomu and his great Empress Komio, in consultation with Giogi. This great monk travelled through the length and breadth of Japan, bearing that proclamation of the Sovereign which announces the project of the great Roshana Buddha of Nara, and then adds, "It is our desire that each peasant shall have the right to add his handful of clay and his strip of grass to the mighty figure," which, we must remember, was intended to be the centre of the Buddhist universe. We can still see, on the petals of the lotus daïs, the various Buddhistic worlds chased with great delicacy.

The Emperor, who called himself publicly "Slave of the Trinity," i.e. the Buddha, the Law, and the Church, assisted with his whole court at the erection. Ladies of the highest rank are said to have carried clay for the model on their brocaded sleeves, and the ceremony of its inauguration must have been most impressive, with the central image, that it had taken more than twenty thousand Japanese pounds of the precious metal to cover with gold. It was surrounded by a halo on which three hundred gold statues were hung, not to speak of the wonderful tapestries and hangings, of which fragments still remain to testify to their past magnificence. A Brahmin monk, named Bodhi, arrived in Japan, and being hailed by the dying Giogi as one come from the sacred land, and therefore more worthy than himself, was invested with the conduct of the inaugural ceremony. Giogi died next day, having thus lived only to see his great life-work completed.

This was an age of tremendous Buddhist activity. Amongst the seven temples at Nara, which vied with each other in gorgeousness, that of Saidaiji is noted for its elaborate architecture, surrounded as it is by golden phoenixes with bells in their mouths. People thought it the work of magic, and worthy to be the palace of a dragon king. They ordered one monastery and one nunnery to be erected in each province of the country, the sites of which are now to be seen from the extreme end of Kiushu to the north of Mutsu.

The Empress Komio was highly instrumental in extending the work of Shomu after his death, and this with the help of her daughter Koken, who was the next to ascend the throne. The nobility of soul of this great Empress-Mother may be felt even in one of her simplest poems, when, speaking of offering flowers to the Buddha, she says, "If I pluck them, the touch of my hand will defile, therefore standing in the meadows as they are I offer these wind-blown flowers to the Buddhas of the past, the present, and the future;" or again, in an outburst of passionate enthusiasm, "The sound of the tools that are raising the image of Buddha let it resound in Heaven! Let it rend the earth asunder! For the sake of the fathers. For the sake of the mothers. For the sake of all mankind." This is the same spirit of grandeur that utters itself in the odes of Hitomaru and other Manyo poets of the Nara period.

The Empress Koken, again, with her masculine mind, was further helpful to the progress of Buddhist art. On one occasion, when the statue of the guardian King Saidaiji was cast, and when, through some mishap, the work failed to succeed, she is said to have personally directed the pouring of molten bronze, which completed the casting.

The colossal Kwannon of Sangatsudo, on whose head is to be seen a silver Amida, ornamented with amber, pearls, and various precious stones, is a statue which ought also to be mentioned amongst the works of this period.

The pictorial art of Nara—as seen in the wall-paintings of Horiuji, which we conclude to be the work of the beginning of the eighth century—is of the highest merit, and shows what the Japanese genius had been able to add, even to the fine workmanship of the wall-painting of the Ajanta caves. A landscape in the imperial collection at Nara, painted on the leather bandage of a musical instrument called the *biwa* (evidently from the Indian "vina"), is so different from the Buddhist style, both in spirit and in execution, as to give us a glimpse into the delicate feeling of the Laoist school of painting under the Tâng dynasty.

This imperial treasure-house (Shosoin) is also remarkable, containing as it does the personal belongings of the Emperor Shomu and his Empress Komio, which their daughter presented to the Roshana Buddha after their deaths, and which have come down undisturbed to the present day. It contains their robes, shoes, musical instruments, mirrors, swords, carpets, screens, and the paper and pen with which they wrote, together with the ceremonial masks, banners, and other religious accoutrements, used on the anniversary of their death, handing down to us in all its luxury and splendour the actual life of nearly twelve hundred years ago. Glass goblets, enamelled cloisonné mirrors, suggestive of Indian or Persian origin, and innumerable specimens of the best Tâng workmanship are there, making the collection a miniature Pompeii or Herculaneum without their catastrophic ashes. By reason of the strict rules which cause it to be opened to spectators of a certain rank once only in each reign, this whole treasure is preserved as if almost a thing of yesterday.

The Heian Period

800 to 900 A.D.

The idea of the union of mind and matter was destined to grow still stronger in Japanese thought, till the complete fusion of the two conceptions should be reached. It is remarkable to find that this fusion rather centres in the material, and the symbol is regarded as realisation, the common act as if it were beatitude, the world itself as the ideal world. There is no Maya after all. In India, while it may be that this feeling of the physical and concrete as a luminous sacrament of spirituality, leads on the one side to Tantrikism and phallic worship, it forms on the other, as we must remember, the living poetry of the home and of experience.

From such conceptions, the sannyasin life is a sequestration, and so it comes that when the Japanese monk of the Shingon sect attempts to express in his worship this notion that the everyday life is not like but is the true life, he adopts for the moment the symbolic marks of the householder.

In this fusion of spirit and form, popular superstitions are raised to the same dignity and seriousness as the authentic sciences. There is no activity that may not receive the attention of the

highest intellect. In this way fine thought and special emotions become democratised; the people lay up immense stores of latent energy, and we accomplish the preparation for some outburst of dynamic faculty at a later era.

In that epoch in Japanese history which is known—from the fact that the capital was then again removed in 794 A.D. from Nara to Heian, or Kyoto—as the Heian period, we find a new wave of Buddhist development, called the Mikkio or Esoteric doctrine, whose philosophic basis is such as to make it capable of including the two extremes, of ascetic self-torture and the worship of physical rapture.

This movement was first represented in China by Vajrabodhi and his nephew Amoghavajra, of Southern India, the latter having gone back to India in quest of such ideas in 741 A.D. This may be considered as the point at which Buddhism merges itself in the larger influx of Hinduism, so that Indian influence at the period is overwhelming, in art as in religion.

The origin of the school in India itself is obscure. There are apparent traces of its existence even in very early days, but its systematisation seems only to be completed in the seventh and eighth centuries, when a need arose for combining the Brahminical and Buddhist doctrines. This was the moment at which the Ramayana received its final form, as a protest against the over-monasticising of life. In Japan the new philosophical standpoint was an advance upon the Hosso and Kegon schools which had taught the union of mind and matter, and the realisation of the Supreme Spirit, in concrete forms, for these thinkers went further than their predecessors, in the effort to demonstrate the idea in practice, claiming their own descent from direct communion with Vairochana, the Supreme Godhead, of which the Sakya-Buddha was only one manifestation. They

aimed at finding truth in all religions and all teachings, each of them being its own method of attaining to the highest.

The union of mind, body, and word in meditation was considered essential, though any one of the three, by itself, carried to its utmost possibility, was productive of the highest results. Thus they made the Word, or the pronouncing of sacred charms, which they considered as lying on the borderland between mind and body, the most important way of attaining the result, so that this sect was sometimes called the True Word, or Shingon.

Art and Nature were now regarded in a new light, for in every object alike was contained Vairochana, the Impersonal-Universal, a supreme realisation of which was to be the quest of the believer. Crime, from this point of view of transcendent one-ness, becomes as sacred as self-sacrifice, the lowest demon as naturally the centre of the pantheon as the highest god. The minutest details must be guarded and conserved, the object being to see the whole of life as an embodiment of Godhead. And mythology comes to be treated as a shimmering iridescence, of which any point may at any moment be made the centre, throwing all others into relative subordination.

The idea is one of many possible issues of the great Indian aspiration towards Same-Sightedness (Samadarsana). At the same time, curiously enough, in spite of the profoundly intellectual analysis inherent in Buddhism, the scientific ideas of this period are expressed as magic, or the study of the supernatural. This was perhaps because the philosophy which divided the Existent into five elements—earth, air, fire, water, and ether understood as Mind, declaring that without the last, no one of the other four could be, and that into it all were alike resolvable—was too subtle for the understanding of the untrained masses. Under this school of thought every act of life became

loaded with ritual, like Indian architecture, as regulated by Varahamihira in his Vrihat Samhita, and sculpture in the Manasara. In erecting a temple, for instance, the acharya, or master, would lay out the ground with a cosmic design, in which every stone had its place, and even the rubbish found within the outline represented the imperfections and shortcomings of his own development. Architecture, sculpture, and the whole arrangement of the temple, were all made expressive of this idea of the universe.

It was under this influence that Buddhism acquired its great masses of gods and goddesses, alien to the faith itself, but made possible by the new teaching as manifestations of the supreme original Divinity. We find now a systematised pantheon, grouped around the idea of Vairochana, in four main subdivisions—first Fudo, second Hosho, third Amida, and fourth Sakya, as representations (1) of Power, which is knowledge; (2) of Wealth, which is creative force; (3) of Mercy, which is Divine intelligence descending upon man; and (4) of Work, or Karma, the realisation of the first three in actual life on earth, that is, Sakya-Muni.

Such is the abstract significance of the symbols. On their concrete side, Fudo, the immovable, the God of Samadhi, stands for the terrible form of Siva, the grand vision of the eternal blue, rising out of fire. Corresponding to the Indian idea of the period, he has the gleaming third eye, the trident sword, and the lasso of snakes. In another form, as Kojin, the Fierce God (Rudra?), or Makeisura (Maha-Iswara), he wears a garland of skulls, armlets of snakes, and the tiger-skin of meditation.

His feminine counterpart appears as Aizen, of the mighty bow, lion-crowned and awful, the God of Love—but love in its strong form, whose fire of purity is death, who slays the beloved that he may attain the highest. Vairochana becomes

a trinity with Fudo and Aizen, by means of the symbol of the Chintamani jewel, whose mystic form is that of a circle striving to make itself a triangle—for life, it is said, never completes itself, but is for ever breaking through perfection, in its struggle upwards to the higher rounds of realisation.

The Indian idea of Kali is also represented by Kariteimo, the Mother-Queen of Heaven, to whom is made offering daily of the pomegranate, under a strange interpretation that points to the transformation of an ancient sacrifice of blood into this form under Buddhistic influences. Saraswati, as Benten, with her vina, which quells the waves; Kompira, or the Gandharva, the Eagle-headed, sacred to mariners; Kichijoten, or Lakshmi, who confers fortune and love; Taigensui, the Commander-in-chief (Kartikeya), who bestows the banner of victory; Shoden, the elephant—headed Ganesh, Breaker of the Path, to whom the first salutations are offered in all village-worship, and whose dread power is held in check by the counsels of the eleven-headed Kwannon, now attaining the female form, in expression of the Indian thought of motherhood—all these suggest the direct adoption of Hindu deities.

This new conception of the divinities is different from the distant attitude of earlier Buddhists, inasmuch as they are now real, concrete, and actual in the forms represented.

The artistic works of the period are full of this intense fervour and nearness to the gods, such as is unknown in any other era. We have seen that the introduction of the Mikkio doctrine into China dates from Vajrabodhi, who came to that land in 719, translated a sûtra on the Yoga, and was followed by Amoghavajra, bringing further knowledge on his return from India in 746. Its introduction into Japan dates similarly from Kukai, who was taught by Keika, the disciple of Amoghavajra. These teachers

were considered to have magical powers, and were held in great reverence, and Kukai, one of the greatest figures in Japanese Buddhism, is supposed to be still sitting in meditation on Mount Koya, where he entered into Samadhi in 833, as a yogi. Kukai's works are numerous, "The Seven Patriarchs of the Sect of the True Word," painted by him, are now handed down in the Toji temple of Kyoto, amongst its priceless treasures, and are deeply suggestive of the great virility and grandeur of this master-mind. His immediate disciples, Jitte, Jikaku, and Chisho, all of whom studied the doctrine in China, carried the movement still further. The creed and temples of the early Nara period succumbed in the main to this new influence, inasmuch as its comprehensive view engendered no conflict with any earlier tenets.

One of the best specimens of the sculpture of this period is the Yakshi Buddha, the Great Healer, carved under the orders of Kukai, now extant in the Zhingoji temple near Kyoto. Another, the eleven-headed Kwannon of Toganji in Omi, is attributed to Saicho, Kukai's great rival. We may also mention the Nioirin Kwannon of Kansinji, and the graceful Kwannon of Hokkiji in Nara.

In painting, the twelve devas by Kukai, preserved at present in Saidaiji in Nara, with the Riokaimandara of Senjuin, of the same province, are the foremost examples of the strong brushwork of the period.

Heian art is thus a synonym for work that is strong and vital, because concrete. It is full of a certain vigour of assurance. But it is not free, lacking the spontaneity and detachment of great idealism. It is at the same time representative of an essential stage in the appropriation of Buddhist conceptions. Up to this point they have been regarded and treated as something apart from the believer himself. Now, in their slightly commonplace energising of the Heian consciousness, this separatedness is lost,

and the succeeding era shows their absorption and re-expression in the national life as emotion.

Notes

Fudo.—The Immovable. One of the Indian names of Siva, similarly, is Achala, the Unmoving.

The Twelve Devas.—The twelve devas are: *Bonten* (Brahma), attended by the white bird *Ha Kuga*, or Swan; *Khaten* (Agni); *Ishanna*; *Thaishak* (Indra); *Futen*; *Vishamon*, whose consort is Kichjoten (Goddess of Fortune); *Em-ma* (Yama), riding on a buffalo, and bearing the great staff of death, surmounted by two heads; *Nitten*, the Sun-God; *Getten*, the Moon-God; *Suiten*, the God of Waters on a tortoise; and *Shoden* (Ganesh).

At the time of a monk's initiation the acharya, or master, represented Vairochana; the postulant, the potential Vairochana; pictures of the twelve devas were hung about the hall as guardian witnesses, and at the back was placed the screen, bearing the representation of mountains and waters, behind which the secret text was spoken in the ear.

Samadhi, or realisation through concentration. In Japan we distinguish three stages, beginning with the trance of super-consciousness, produced by meditation, and culminating in a perfect union with the Absolute, which is compatible with work in the world, and is the same as Buddhahood. This last phase is that known in India as jivan-mukti.

The Fujiwara Period

900 to 1200 A.D.

The Fujiwara period dates from the ripened ascendency of that family at the accession of the Emperor Daigo, 898 A.D. With it begins a new development in Japanese art and culture, which may be termed the *national*, in contrast to the predominating *continental* ideas of preceding epochs. All that was best in Chinese thought and Indian wisdom had long found its way to Japan, till now the pent-up energy of this assimilated culture was precipitating the race upon the evolution of its own special forms, both in life and in ideals.

For the national mind may be held, in the Heian period, to have completed the apprehension of the Indian ideal. And now, according to mental habit, it isolates it, and makes its realisation its solitary purpose. In this the Japanese, by their greater Indian affinity, enjoy an advantage over the Chinese, who are withheld by that strong common sense which is expressed in Confucianism, from the unbalanced development of any single motive to its full intensity.

Those disturbances in China which, towards the close of the Tâng dynasty, prevented the exchange of diplomatic amenities

between the two countries, and the conscious dependence which Japan began to place on her own power, induced the statesmen of the time—amongst whom stands that Michizane who is so revered as Tenjin, patron of letters and learning—to resolve on sending no more embassies to Choan, and to cease borrowing further from Chinese institutions. A new era began, in which Japan strove to create a system of her own, based on the revival of purely Yamato ideals, for the administration of civil and religious affairs.

This new development is marked in letters by the appearance of important books, written in Japanese by women. For till now, in comparison with the classic Chinese style of the scholars, the vernacular language had been considered effeminate, and was left to become the proper instrument of woman only. So dawned the great era of feminine literature, in the course of which may be mentioned Murasa ki Shikibu, authoress of the grand romance of Genji; Seishonagon, whose sarcastic pen anticipates, by seven hundred years, Madame Scudery's witticisms on the court scandals of the *Grand Monarque*; Akazome, noted for her peaceful and pure conception of life; and Komachi, the great sad poetess, whose life exemplifies the loves and sorrows of that refined and voluptuous epoch. Men imitated the style of these ladies, for this was, *par excellence*, the age of woman.

Confined in their island home, with no questions of state to trouble their sweet reveries, the court aristocracy found their serious occupation in art and poetry. The lesser duties of state-craft were left to inferiors, for to the over-refinement of the time it appeared that useful duties were both lowering and impure, so that the handling of money and the use of arms were functions fit only for the menial classes.

Even the administration of justice was relegated to the lower orders. Governors of provinces would almost spend their lives in the capital, Kyoto, leaving their representatives and henchmen to take charge of their local duties, and some were even heard to make the proud boast that they had never left the metropolis.

To Buddhism, still the dominant element in the nation's range of variation, the halo of the eternal feminine draws closer in the Jodo ideal of the Fujiwara epoch than at any other moment in its history. The strict and masculine discipline of the monk-taught doctrines of preceding ages—seeking salvation through personal effort and self-mastery alone—had brought about its own reaction, and the movement of revolt coincided with a renewal of that Tendai conception of the Buddhistic idea, prevalent in the Asuka or pre-Nara period, when perfection was regarded as attainable by mere contemplation of the Abstract-Absolute. Thus the religious consciousness, exhausted by despair of the terrible struggle for Samadhi through renunciation, swings back upon the thought of the madness of supreme love. The prayer which dissolves the self into union with the ocean of infinite mercy takes the place of the proud assertion of the privilege of manhood in self-realisation. So, in India, also, Sankaracharya is succeeded by Ramanuja and Chaitanya, an age of Bhakti succeeds an age of Jnan.

A wave of religious emotion passed over Japan in the Fujiwara epoch, and, intoxicated with frantic love, men and women deserted the cities and villages in crowds to follow Kuya or Ipen, dancing and singing the name of Amida as they went. Masquerades came into vogue, representing angels descending from Heaven with the lotus daïs, in order to welcome and bear upward the departing soul. Ladies would spend a lifetime

in weaving or embroidering the image of Divine Mercy, out of threads extracted from the lotus-stem. Such was the new movement, which, however closely paralleled in China, in the beginning of the Tâng dynasty, was nevertheless so completely and distinctively Japanese. It has never died, and to this day two-thirds of the people belong to this Jodo sect, which corresponds to the Vaishnavism of India.

Both Genshin, the formulator of the creed, and Genku, who carried it to its culmination, pleaded that human nature was weak and, try as it might, could not accomplish entire self-conquest and direct attainment of the Divine in this life. It was rather by the mercy of the Amida Buddha and his emanation, Kwannon, that one could alone be saved. They did not put themselves in conflict with the earlier sects, but, leaving them to work out, each its own results in its own way, declared that it was for strong natures and rare individuals to develop by what they called *Shodo*, or the Path of Saints, while for the ordinary masses a prayer, even a single prayer, addressed to the almost maternal Godhead, represented in Amida, the Immeasurable Light, was enough to draw the soul into His world of purity, called the *Jodo*, where, free from the pains and evils of this wretched life, they could evolve into the Buddhahood itself.

This prayer they called "the easier path," and their images, softened by the spirit of femininity, produced a new type, very different from those of the stately Buddhas, and fierce representations of the Divine wrath, known to the preceding age as the Siva-like *Fudo*, Destroyer of Earthly Passion and Sentiment. Shinran, a disciple of Genku, founded the Honganji sect, now the most powerful in the country, of the adherents of this idea.

Japanese painting, with its delicate lines and refined colours, begins now to be characterised, from the tenth century onwards,

by a predominating use of gold, which, not unlike the gold backgrounds of mediæval artists in Europe, is explained by the argument that yellow light must permeate the regions of Amida.

Its subjects of illustration are the Kingdom of Amida, or ideal Mercy, the Kwannon of Seishi, or ideal Power, and the twenty-five Angels, who, with their heavenly music, escorted spirits into Paradise. There is no better representation of this idea than in the grand picture of Amida and the twenty-five Angels by Genshin himself—which picture is now kept in Koyashan.

The sculpture of the period rose to its greatest height in Jocho (of the eleventh century), whose Amida is still to be seen in all its glory at Hoodo, in Uji, one of the innumerable temples which the Fujiwara ministers consecrated to the new Jodo, or Faith in the Land of Purity. The Fudo of this sculptor is so sweet as to be almost an Amida—a fact which is significant of the strength of that feminine influence that could change even the mighty form of Siva himself.

But, alas! in a world so worldly, no such dreamland could long persist! The storm was already brewing in the provinces that was to scatter to the four winds that festival of flowers which reigned in Kyoto, the capital. Each local disturbance added to the power of those provincial magistrates who actually held the reins of government, and ultimately constituted them the daimyos and barons of succeeding ages. Revolts in the North gave an opportunity to the martial family of Minamoto, and their long campaign of fifteen years won the hearts of the uncivilised peoples east of the Hakone Pass, who were almost as much dreaded by the people of the court as the hordes of Goths by the later Romans. The suppression of pirates in the Inland Sea also called into prominence the power of the Taira, so that towards the end of the eleventh century the military strength of the empire was divided between

these two rival families of Minamoto and Taira. The aristocracy of the court—pleading in their extreme effeminacy that the true man was a combination of man and woman—were going so far as to imitate women in painting their faces and in their attire, and could not, in their frivolity, understand the danger that was threatening them so close.

A civil war between two aspirants for the imperial throne in the middle of the twelfth century completely unmasked the powerlessness of the Fujiwara court. The Commander-in-chief of the forces was not even able to mount his horse, and the Captain of the Imperial Guard found it impossible to move, in the heavy armour which had become fashionable at the period. In this dilemma the warlike families of Minamoto and Taira, held in contempt by the court, and treated as an almost inferior class. though they were both descended from the imperial loins, were necessarily called in to assist the rivals for the throne.

The family of that imperial candidate who was supported by the Taira arms gained the ascendency, and held it close on half a century. Then they succumbed to the habits and ideals of the Fujiwaras, so as completely to lose their valour. The scion of the Minamotos found them then an easy prey, and all their power and prestige were destroyed in the epic battles of Suma and Shioya.

Notes

Choan is the present city of Suiang, in the viceroyalty of Shenshi, where the Empress-Dowager took refuge recently, during the unfortunate occupation of Pekin by the Allies. Choan, with Rakuio or Loyang, formed the two chief capitals of the Hâng

and Tâng dynasties. In this and other cases we have followed the Japanese pronunciation of Chinese names.

Bhakti.—That love of God, and devotion in love, which attains to selflessness. In Europe St. Teresa and some of the modern Protestant sects may stand as examples.

Gnan.—That supreme illumination of the intellect in which the transcendent oneness of all things becomes self-evident.

Sankaracharya.—The greatest Hindu saint and commentator of modern times. He lived in the eighth century, and is the father of modern Hinduism. He died at the age of 32.

Ramanuja.—A saint and philosopher of the Bhakti-type. He lived in Southern India in the twelfth century. He is the founder of the second great school of the Vedanta philosophy.

Chaitanya.—Known as the "Prophet of Nuddea," in Bengal, an ecstatic saint of the thirteenth century.

Suma and Shioya.—Two places near Kobe, Japan.

The Kamakura Period

1200–1400 A.D.

With the establishment of the Shogunate, or military vice-royalty by Yoritomo of the Minamoto family at Kamakura, in 1186 A.D., begins a new phase of Japanese life, whose main features continued till the Meiji restoration of the present day.

This Kamakura epoch is important as the connecting-link between the Fujiwara on the one hand and the Ashikaga and Tokugawa epochs on the other. It is characterised by the development in full form of the notion of feudal rights and individual consciousness. And it is interesting, like all transition periods, by the fact that it contains, in solution as it were, those developments whose complete self-display had to await a later era. Here we find the idea of individualism struggling to express itself among the decaying débris of an aristocratic rule, inaugurating an age of hero-worship and heroic romance akin to the spirit of European individualism in the time of chivalry, its woman-worship restricted by Oriental notions of decorum, and its religion—by reason of the freedom and ease of the Jodo sect—lacking the severe asceticism of that over-awing popedom

which held the Western conscience in iron fetters. The division of the country into feudal tenures, headed by the noble and powerful family of Minamoto at Kamakura, led each province to find amongst its own lords and knights some central figure who represented for it the highest personification of manhood. The influx upon the people who lived in the trans-Hakone region of the so-called Eastern Barbarians with their simple bravery and unsophisticated ideas, broke down the effeminate complexity left by the over-refined formalism of the Fujiwaras. Each local knight strove hard as against all others, not only in martial prowess, but in the power of self-conquest, courtesy, and charity, which were qualities considered above muscular might, as the marks of true courage.

"To know the sadness of things" was the motto of the time, so bringing to birth the great ideal of the Samurai, whose *raison d'être* was to suffer for the sake of others, Indeed, the very etiquette of this knightly class during the Kamakura period points as unmistakably to the conception of the monk, as the life of any Indian woman to that of the nun. Some of the Samurai, or military officers, grouped around their chiefs or daimyos, and followed in turn by their own clansmen, wore a priestly garment over their armour, and many even went the length of shaving the head. There was nothing incongruous with religion in the art of war, and the noble who renounced the world became one of the militant monks of his new order. The Indian idea of the Guru, or giver of spiritual life, was here projected upon the Samurai's war-lord, whoever he might be, and a surging passion of loyalty to "the banner-chief," became the motive of a career. Men would devote their lives to the avenging of his death, as in other countries women have died for their husbands, or the worshipper for his gods.

It is possible that this fire of monasticism has been the great influence in robbing Japanese chivalry of its romantic element. The idealising of women would seem to have been an instinctive note of early Japanese life. Were we not of the race of the Sun-goddess? Only after the Fujiwara epoch, with its exploration of the realm of religious emotion, the devotion of man to woman amongst us assumes its true Eastern form, of a worship the more powerful because the shrine is secret, an inspiration the stronger because its source is hidden. A reserve as of religion seals the lips of Kamakura poets, but it must not be thought on that account that the Japanese woman was not adored. For the seclusion of Oriental zenanas is a veiled sainthood. It may have been in the Crusades that the troubadours learnt this secret of the strength of mystery. It will be remembered that their most binding tradition was the obscurity in which the name of "my lady" was involved. Dante, at any rate, as a singer of love, is entirely an Eastern poet singing of Beatrice, the Oriental woman.

This was an age, then, of silence as to love, but it was also an age of epic heroism, in the midst of which looms large the romantic figure of Yoshitsune, of the house of Minamoto, whose life recalls the tales of the round table, and is lost, like that of the knight of Pendragon, in poetic mist, so as to furnish the imagination of a later day with plausible grounds for identifying him with Genghis Khan in Mongolia, whose wonderful career begins about fifteen years after the disappearance of Yoshitsune in Yezo. His name is also pronounced Ghengi Khei, and some of the names of the generals of the great Mogol conqueror bear resemblance to those of the knights of Yoshitsune. We have also Tokiyorie, the regent of the Shoguns, who, like Haroun-al-Raschid, travelled through the Empire alone as a simple monk, inquiring into the state of the country. These episodes give rise

to a literature of adventure, which, centring on some heroic
character, is rigorous in its rude simplicity, in contrast to the
elegant effeminacy of preceding Fujiwara writings.

Buddhism had to be simplified in order to meet the require-
ments of this new age. The Jōdo ideal now appeals to the public
mind, through grosser representations of retribution. Pictures of
purgatory and the horrors of hell are for the first time presented,
in order to over-awe the rising populace, who under this new
régime were becoming more prominent than before. At the same
time, the Samurai, or knightly class, adopted as its ideal the
teaching of the Zen sect (perfected under the Sung dynasty, by
the Southern Chinese mind), that salvation was to be looked for
in self-control and strength of will. Thus the art of this period
lacks both the idealised perfection of the Nara and the refined
delicacy of the Fujiwara, epochs, but is characterised by the
vigour of its return to the line, and by the virility and strength
of its delineation.

Portrait statues, so significant a production of the heroic age,
now claim the foremost place in sculpture. Among these may be
mentioned the statues of monks of the Kegon sect in Kofukuji in
Nara, and several others. Even the Buddhas and devas assume
personal characteristics, as may be seen from the great Nioo of
Nandaimon in Nara. The fine bronze Buddha of Kamakura is
not exempt from the human tenderness which is absent from
the more abstract bronzes of Nara and Fujiwara.

Painting lent itself, besides portraiture, to the illustration
of the heroic legends, generally in the form of makimonos, or
rolls, in which the pictures are interspersed with the written
text. No subjects were too high or too low for the artists of the
day to illustrate, as the formalist canons of aristocratic distinc-
tion were discarded in the new-born enthusiasm of individual

consciousness; but what they most delighted to paint was the spirit of motion. Nothing is more illustrative of this than the wonderful street scenes, depicted in the makimono owned by Prince Tokugawa, of Bandainagon, or the three battle-scenes of the Heiji stories, owned by the Emperor, Baron Iwasaki, and the Boston Museum. These are falsely attributed to Keion, an artist whose very existence is without foundation.

The gorgeous succession of depictments of the terrors of hell in the makimonos of Jigokusoshi and Tenjinengi of Kitano—where the warlike spirit of the time seems to delight in the awful spectacle of destruction and sublime horror—suggests the imagery of Dante's Inferno.

Notes

Shogunate.—Shogun is an abbreviation of *Seyi tai Shogun*, or Commander-in-Chief of the Armies that fight the Barbarians. This title was first conferred on Yoritomo of the Minamoto family, who destroyed the Tairas. The long succession of military regents of Japan, after this date, were called Shoguns, and of them, the Minamotos reigned in Kamakura, the Ashikagas in Kyoto, and the Tokugawas in Yedo (Tokio).

Sakti.—A Sanscrit word meaning force or power, the cosmic energy. It is always symbolised by the feminine, as Durga, Kali, and others. All women are supposed to be its embodiment.

Sûtras.—Sûtra, in Sanscrit, means *thread*, and is a term applied to certain of the ancient texts, which consist of aphorisms or part-aphorisms, and are necessarily obscure by reason of their conciseness. They belong to the old system of memorising, and

are really a series of suggestions covering the whole ground of an argument, in which catch sentence is intended to revive the memory of certain steps. The corresponding word in Chinese is *warp*, that which is to be woven upon.

Ashikaga Period

1400–1600 A.D.

The Ashikaga period is named from that branch of the Minamoto family who succeeded to the Shogunate. It sounds, natural outcome as it is of Kamakura hero-worship, the true note of modern art, Romanticism in its literary sense.

The conquest of Matter by the Spirit has been always the purpose of the striving of world-forces, and each stage of culture is marked, alike in East and West, by an intensifying of the attitude of triumph. The three terms by which European scholars love to distinguish the past development of art, though lacking perhaps in precision, have nevertheless an inevitable truth, since the fundamental law of life and progress underlies not only the history of art as a whole, but also the appearance and growth of individual artists and their schools.

The East has had its own form of that period called *Symbolic*, or better still, perhaps, *Formalistic*, when matter, or the law of material form, dominates the spiritual in art. The Egyptian and Assyrian sought by immense stones to express grandeur, as the Indian worker by his innumerable repetitions to utter forth infinity in his creations. Similarly, the Chinese mind of the Shu and Hang

dynasties pursued sublime effects in their long walls, and in the intricately subtle lines which they produced in bronze. The first period of Japanese art, from its birth to the beginning of the Nara era, however imbued with the purest ideal of the first Northern development of Buddhism, still falls into this group, by making form and formalistic beauty the foundation of artistic excellence.

Next comes the so-called *Classic* period when beauty is sought as the union of spirit and matter. To this impulse, Greek Pantheistic philosophy in all its phases devotes itself, and the works of the Parthenon, with the immortal stones of Phidias and Praxiteles, are its purest expression. This phase is manifested in the East also as the second school of Northern Buddhism.

Here we have an objective idealism, which reaches its height, under the influence of the India of the Guptas, during the Tâng dynasty and the Nara period, and is destined to be hardened into the concrete cosmology of the Esoteric pantheon. The kinship between Japanese work of this period and that of the Greco-Romans is due to the fundamental resemblance of its mental environment to that of the classic nations of the West.

But individualism, the underlying fire of modern life and speculation, was only waiting to leap through the classic crust and flame up once for all into the freedom of the spirit. Spirit must conquer Matter, and though the differing idiosyncrasies of the Occidental and the Oriental mind lead to differing expression, the modern idea of the whole world runs inevitably to Romanticism. The Latin and Teutonic races, from their hereditary instincts and political positions, went forth to seek the Romantistic ideal objectively and materialistically; whereas the later Chinese mind, as represented by the Neo-Confucians, and the Japanese since the days of Ashikaga, steeped as it were in the spiritual essence of Indian, and imbued with the harmonistic

communism of Confucian thought, approached the problem from a subjective and idealistic standpoint.

The Neo-Confucian influence of China, which ripened later under the Sung dynasty (A.D. 960-1280), was an amalgamation of Taoist, Buddhist, and Confucian thought, acting chiefly, however, through the Taoist mind, as shown in Chimpaku, that Taoist philosopher at the close of the Tâng dynasty, who made a single diagram to represent the universe according to all these systems at once. We come now upon the new interpretations of the two principles of the Cosmos, the male and female, with stress laid for the first time upon the latter, as the alone-active. This corresponds to the Indian notion of the Sakti, and was developed by Neo-Confucian thinkers as their theory of Ri and Ki, the all pervading Law, and the working Spirit. Thus all Asiatic philosophy, from Sankaracharya downwards, turns on the moving power of the universe.

Another tendency of the Taoist mind is the flight from man to nature. This is a consequence of the fact that we seek expression in opposites. This innate love of nature imposes a limitation on the Ashikaga art, which devotes itself too exclusively to landscapes, birds, and flowers. Thus Neo—Confucianism in China consists of the Confucian justification of all, *plus* the new spirit of individualism, and it culminates in the revival of the polity of Shu with a deepened modern significance.

It is a proof of the reality of the individualism of the epoch that the movement is succeeded by the rise of great political parties in the empire, thus weakening China against her next Tartar invasion, which resulted in the Mongol dynasty of Gen (A.D. 1280-1368).

Japanese art ever since the days of the Ashikaga masters, though subjected to slight degeneration in the Toyotomi and

Tokugawa periods, has held steadily to the Oriental Romantistic ideal—that is to say, the expression of the Spirit as the highest effort in art. This spirituality, with us, was not the ascetic purism of the early Christian fathers, nor yet the allegorical idealisation of the pseudo-renaissance. It was neither a mannerism, nor a self-restraint. Spirituality was conceived as the essence or life of a thing, the characterisation of the soul of things, a burning fire within.

Beauty was the vital principle that pervaded the universe—sparkling in the light of the stars, in the glow of the flowers, in the motion of a passing cloud, or the movements of the flowing water. The great World-soul permeated men and nature alike, and by contemplation of the world-life expanded before us.; in the wonderful phenomena of existence, might be found the mirror in which the artistic mind could reflect itself. Thus the art of Ashikaga bears an entirely different aspect from the productions of the two preceding phases. It is not replete and harmonious, like the formalistic beauty of the Hang bronzes or the mirrors of the Six Dynasties, nor is it full of that calm pathos and emotional repose which we find in the statues of the Sangatsude of Nara and the finished glory and refined ideality of the Genshin's Angels of Koyasan, yet it impresses one with a directness and unity which cannot be found in these earlier creations. It is mind speaking to mind, a mind strong and self-refusing—unmoved, because it is so simple.

That identity of mind and matter which had been the evolving and culminating ideal of the pre-Fujiwara periods of Japanese art always means repose. It is the centripetal effort of the imagination. But the latent energy breaks forth anew. Life reasserts itself in the centrifugal impulse. Strange new types create themselves. Individuality becomes rich in its variety and strength.

The first expression is always in emotion, the *Bhakti* of Indian thought, as we see it in the love-stories and poems of Europe, and in the religious developments of the Fujiwara epoch. Later, as here in the Ashikaga period, we have the higher phase, in that realisation of the sum of things as the act of our own will which in India is called *Gnan*, or "insight."

The Ashikaga ideal owes its origin to the Zen sect of Buddhism, which became predominant during the Kamakura period. *Zen*, from the word *Dhyan*, meaning meditation in supreme repose, was introduced into China through Bodhi Dharma, an Indian prince who reached that country as a monk in A.D. 520. But it had first to assimilate Laoist ideas, before it could be naturalised on Celestial soil, and in this form it made its advent, towards the end of the Tâng dynasty. The doctrines of Baso and Rinzai are clearly demarcated from those of the early exponents of this school. Zenism, therefore, was a development, and the inheritance which it left to be handed down by the Kamakura and Ashikaga monks was the Southern, differing greatly from the Northern Zen, which latter adhered still to the form that had been taught by the early patriarchs of the sect. For by this time the idea had become nothing less than a school of individualism. Under its inspiration, the militant heroes of Kamakura were as the spiritual heroes of the church—Alexander stood transformed as Ignatius Loyola. The idea of conquest was completely orientalised, in passing from that which is without to that which is within a man himself. Not to *use* the sword, but to *be* the sword—pure, serene, immovable, pointing ever to the polar star—was the ideal of the Ashikaga knight. Everything was sought in the soul, as a means of freeing thought from the fetters in which all forms of knowledge tended to enchain it. Zenism was even iconoclastic, in the sense of ignoring forms

and rituals, for Buddhist images were cast into the fire by the Zen who obtained enlightenment. Words were considered an encumbrance to thought, and the Zenistic doctrines were set forth in broken sentences and powerful metaphor, to the great disparagement of the studied language of the Chinese literati.

The human soul, to these thinkers, was itself the Buddhahood in which the universal, as manifested in the particular, became resplendent with that original glory which had been lost through the long night of ignorance and so-called human knowledge. By freeing thought from the trammels of mistaken categories true enlightenment was to be attained.

Thus their training was centred on the methods of that self-control which is the essence of true freedom. Deluded human minds groped in darkness, because they mistook the attribute for the substance. Even religious teachings were misleading, in so far as they set up semblances for realities. This thought was often illustrated by the simile of monkeys attempting to seize the reflection of the moon in water; for each effort to snatch at the silvery image could but ruffle the mirroring surface, and end in destroying not only the phantom moon, but also themselves. The elaborate sûtras of the so-called eighty-four thousand gates of knowledge were like the meaningless chatter of the apish scholars. Freedom, once attained, left all men to revel and glory in the beauties of the whole universe. They were then one with nature, whose pulse they felt beating simultaneously within themselves, whose breath they felt themselves inhaling and exhaling in union with the great world-spirit. Life was microcosmic and macrocosmic at once. Life and death alike but Phases of the one existence universal.

They loved also to portray the progress of a Zen student as a cowherd in search of a lost charge. For man through ignorance

is bereft of his soul, and, like the cowherd, once roused for the search, he trudges on in the almost imperceptible footprints, till he discovers first the tail and then the body of that which he seeks. Next ensues the struggle for mastery—a fierce combat and terrible warfare between the mundane senses and the inner light. The herdsman conquers, and, seated on the back of the now docile animal, goes serenely on his way, playing a simple melody on the flute—thus he forgets himself and the beast. To him day is sweet, with its green willows and crimson flowers. These vanish again, and he delights to move about in the pure moonlight, where at once he is and yet is not. Thus, to Zen thinking, victories over the inner self are more true than the austere penances of the mediæval hermit, who tormented his flesh instead of disciplining his mind. The body is a crystal vessel, through which the rainbow of the Great Existence is to shine. The mind is like a great lake, clear to its bottom, reflecting the clouds that hover over it, sometimes ruffled by winds which make it foam and rage, but only to settle down into the original calm, never losing its purity, or its own nature. The world is full of a pathos of existence which is yet merely incidental, and one must battle and war with serenity and imperturbability, as if going to a bridal feast. Life and art, as influenced by these teachings, wrought changes in Japanese habits which have now become a second nature. Our etiquette begins with learning how to offer a fan, and ends with the rites for committing suicide. The very tea-ceremony is made expressive of Zen ideas.

The Ashikaga aristocracy, exquisites in their own way, worked, like their Fujiwara ancestors, from the notion of luxury to that of refinement. They loved to live in thatched cottages, as simple in appearance as those of the meanest peasant, yet whose proportions were designed by the highest genius of Shojo or Soami,

whose pillars were of the costliest incense-wood from the far-
thest Indian islands; even whose iron kettles were marvels of
workmanship, designed by Sesshu. Beauty, said they, or the life
of things, is always deeper as hidden within than as outwardly
expressed, even as the life of the universe beats always under-
neath incidental appearances. Not to display, but to suggest,
is the secret of infinity. Perfection, like all maturity, fails to
impress, because of its limitation of growth.

Thus it would be their joy to ornament an ink-box, for
instance, with simple lacquering on the outside, and in its hid-
den parts with costly gold-work. The tea-room would be deco-
rated with a single picture or a simple flower-vase, to give it
unity and concentration, and all the riches of the daimyo's col-
lections would be kept in his treasure-house, whence each was
brought out in turn to serve in the satisfaction of some æsthetic
impulse. Even to the present day the people wear their costliest
stuffs for under-garments, as the Samurai prided themselves
on keeping wonderful sword-blades within unpretentious scab-
bards. That law of change which is the guiding thread of life
is also the law which governs beauty. Virility and activity were
necessary in order to make an everlasting impression; but leaving
to the imagination to suggest to itself the completion of an idea
was essential to all forms of artistic expression, for thus was the
spectator made one with the artist. The uncovered silken end
of a great masterpiece is often more replete with meaning than
the painted part itself.

The Sung dynasty was a great age of art and art-criticism.
Their painters, especially from the time of Emperor Kiso, in the
twelfth century, himself a great artist and a patron, had shown
some appreciation of this spirit, as we see in Bayen and Kakei,

in Mokkei and Riokai, whose small works express vast ideas. But it required the artists of Ashikaga, representing the Indian trend of the Japanese mind released from Confucian formalism, to absorb the Zen idea in all its intensity and purity. They were all Zen priests, or laymen who lived almost like monks. The natural tendency of artistic form under this influence was pure, solemn, and full of simplicity.

The strong, high-toned drawing and colouring, and the delicate curves of Fujiwara and Kamakura, were now discarded for simple ink-sketches and a few bold lines—just as they discarded their graceful robes, assuming huge stiff trousers in their place—for the new idea was to divest art of foreign elements, and to make expression as simple and direct as possible. Ink-painting, an innovation begun at the close of the Kamakura period, now supersedes colour in importance.

A painting, which is a universe in itself, must conform to the laws that govern all existence. Composition is like the creation of the world, holding in itself the constructive laws that give it life. Thus a great work by Sesshu or Sesson is not a depictment of nature, but an essay on nature; to them there is neither high nor low, neither noble nor refined. A picture of the goddess Kwannon, or of Sakya, will be no more important a subject than a painting of a single flower or a spray of bamboo. Each stroke has its moment of life and death; all together assist to interpret an idea, which is fife within life.

The two most prominent artists of this period are, undoubtedly, these masters, though the way was paved for them by Shitibun, noted for his landscapes and juicy ink touches.

Jasoku is another, whose vigour of stroke and compact composition are almost unequalled.

Sesshu owes his position to that directness and self-control so typical of the Zen mind. Face to face with his paintings, we learn the security and calm which no other artist ever gives.

To Sesson, on the other hand, belong the freedom, ease, and playfulness which constituted another essential trait of the Zen ideal. It is as if to him the whole of experience were but a pastime, and his strong soul could take delight in all the exuberance of virile nature.

Hosts of others follow in the wake of these—Noami, Gaiami, Soami, Sotan, Keishoki, Masanobu, Motonobu, and a galaxy of illustrious names fill this period, which is unparalleled by any other. For the Ashikaga Shoguns were great patrons of art, and the life of the age was conducive to culture and refinement.

But it is impossible to pass from the consideration of the Ashikaga era without some reference to its development of music, for nothing is so indicative of the spirituality of an art-impulse, and it is during the Ashikaga period that our national music emerges in its maturity.

Before this, except for the simple old songs of the people, we had only that Bugaku music of the latter part of the Six Dynasties, which, while derived from India and China, is yet so closely akin to the Greek. And this is natural, since all alike must have been but off-shoots from the common stem of early Asiatic song and melody. This Bugaku music has never been forgotten. We can still hear it played in Japan in the old costumes, to the old steps, thanks to its preservation by a hereditary caste. It has now grown, perhaps, a little mechanical and expression-less, but the Hymn to Apollo could still be played in its own mode by the Bugaku musicians.

True to the needs of a military age, the Kamakura period produced the Bards, who sang epic ballads of the glory of the

heroes. The masquerades of the Fujiwara epoch also found dramatic development later, in representations of Hell, given in recitative to a simple accompaniment. These two elements gradually fused and became permeated by the historic spirit, so giving birth, towards the opening of the Ashikaga period, to those No-dances, which are likely, from their consecration to great national themes of struggle and event, to remain always one of the strongest elements in Japanese music and drama.

The stage on which the No-dance is performed is made of hard, unpainted wood, with a single pine tree somewhat conventionally portrayed on the background. Thus is suggested a grand monotony. The main parts are three in number, the small chorus and orchestra being seated on the stage at one side. Masks are worn by the chief players—who might almost better be termed *tellers*—and assist in the general idealisation. The poem deals with historical subjects, always interpreting them through Buddhist ideas. The standard of excellence is an infinite suggestiveness, naturalism the one thing to be condemned.

Under these conditions, relieved only by slight comic interludes, an audience will sit spell-bound through a whole day. The short epic drama that composes the No-dance is full of semi-articulate sounds. The soughing of the wind amongst the pine boughs, the dropping of water, or the tolling of distant bells, the stifling of sobs, the clash and clang of war, echoes of the weavers beating the new web against the wooden beam, the cry of the crickets, and all those manifold voices of night and nature, where pause is more significant than pitch, are there. Such dim utterances, echoed from the eternal melody of silence, may seem to the ignorant curious or barbaric. But there can be little doubt that they constitute the insignia of a great art. They never allow us to forget for a moment that the No-dance is a direct appeal

from mind to mind, a mode by which unspoken thought is borne from behind the actor to that unhearing and unheard intelligence that broods within the heart of him who listens.

Toyotomi and Early Tokugawa Period

1600–1700 A.D.

The Ashikaga rule, weakened by the factions of the two families, Yamana and Hosokawa who, as regents of the Shoguns, were dominant, gave way by degrees before the rising power of the feudal barons. The country was in a constant state of war, with perpetual conflicts between each two neighbouring daimyos, among whom rose sometimes a great mind that would form the design of unifying the empire by obtaining a hold over the capital where the emperor resided. The history of the whole period is simply the narrative of so many rival attempts to reach Kyoto.

Ota-Nobunaga, who, with Toyotomi Hideyoshi and Tokugawa Iyeyasu forms a triple power, each in turn constituting the great representative force of his day, at last accomplished the task. It was Nobunaga who, from his *place d'avantage* in central Japan, was able to wedge himself into the focus of the conflicting movements, and replace the Ashikaga Shoguns in his own person as military dictator of more than half baronial Japan. It was Hideyoshi who, as the greatest general of Nobunaga, succeeded to his influence and completed the subjugation of the rival chiefs,

leaving the country again at his death to be consolidated under the strict régime of the wary statesman, Iyeyasu.

Thus the central figure of this period is that of Hideyoshi, a man who rose from the lowest rank to the highest dignity in the empire in 1586 A.D., and to whose towering ambition Japan was so much too small a sphere as to lead him to attempt the conquest of China, an idea which brought about the disastrous devastation of Corea, and the humiliating recall of Japanese troops from the peninsula on his death in 1598.

Like their illustrious leader, the new nobility of that period were men who had created their own ancestry with their swords; some were recruited from the banditti of the land, and some from the piratical captains who were such a terror to the people of the Chinese coast; and naturally, to their uncultured mind, the solemn and severe refinement of the Ashikaga princes was distasteful, because unintelligible. They, instigated by Hideyoshi, often indulged in the subtle pleasures of the tea-ceremony, yet even this meant for them rather the enjoyment of displaying their riches than any true refinement.

The art of this period is more remarkable, therefore, for its gorgeousness and wealth of colour than for its inner significance. The decoration of palaces in the style of Ming, rich with decadent elaborateness, was suggested to them by their intercourse with the Koreans and Chinese, through the continental war.

New palaces were needed for the new daimyos, which, by their size and magnificence, outshone the simpler dwellings even of the Ashikaga Shoguns. This was the age of stone castles, whose plans were influenced by Portuguese engineers. Of these, the foremost was that of Osaka, planned by Hideyoshi himself, the construction of which was assisted by all the daimyos

throughout the country, so as to make it impregnable even to the military genius of Iyeyasu.

That of Momoyama, near Kyoto, was also a grand masterpiece in this kind of construction, attracting the admiration of the whole nation by its splendour and magnificence. Here the whole wealth of artistic decoration was lavished to the utmost, so that had it survived the memorable earthquake of 1596 and subsequent destructive fire of war, the glory of Nikko would have paled before it, because the Nikko is a mere imitation of what artists call now the Momoyama style. Momoyama was the Versailles which all the barons or daimyos imitated, every country castle being made a miniature Momoyama in itself.

Now was discovered the wonderful usefulness of gold-leaf, employed so much ever since that day as decoration for walls and screens. Some screens of the celebrated "hundred sets" belonging to the palace-castle are still preserved, as well as some of those which adorned the wayside for miles during the processions of Hideyoshi. Huge pines were painted on a scale of forty or fifty feet in breadth to cover the walls of audience-chambers. Hot-tempered daimyos rained down their orders simultaneously on weary artists, sometimes demanding a palace, with decorations, to be completed in a day. And Kano Yeitoku, with his multitude of pupils, worked on, painting the immense forests, the birds of gorgeous plumage, and the lions and tigers that symbolised courage and royalty, in the midst of all the magnificent turmoil of their patrons.

Tokugawa Iyeyasu, who came into power after the second storming of the Osaka Castle in 1615, unified the administrative system throughout the land, and put it, with his wonderful statesmanship, upon a new régime of simplicity and solidarity.

Alike in art and manners he strove to return to the Ashikaga ideal. His court painters—Tannyu and his brothers, Naonobu and Yasunobu, with their nephew, Tsunenobu—made it their aim to imitate the purity of Sesshu, but failed, of course, to touch his real significance. The age was alive with the virility of a race only just awakened from sleep, evincing now for the first time the naive delight of a populace but newly made free of the world of art. In this Japanese society anticipates by two hundred years some of the most striking features of the nineteenth century of Europe. The manners and loves of the time were for display and not simplicity, and this, even as late as the era of Genroku, a century after the establishment of the Tokugawa Shogunate.

The architecture of early Tokugawa followed mainly, as said before, the characteristics of Toyotomi, of which fact we find examples in the mausoleums of Nikko and Shiba, and in the palace decorations of the Nijo Castle, and the Nishi Hoganji Temple.

The breaking down of social distinctions, which was brought about by the upheaval of the new aristocracy, permeated art with a spirit of democracy hitherto unknown.

Here we find the beginning of the Ukiyoe or Popular School, though its conceptions at this time differed widely from those of the later Tokugawa genre school, where intense class-distinctions imposed their limitations on plebeian conceptions. In this age of wild revelry, while pleasure was yet sweet to the nation, freed from half a century of bloodshed, whenever the people would vent their energies in juvenile playfulness and fantastic images, the daimyos would join with the populace in unrestrained enjoyment.

Sanraku, the able successor and adopted son of Yeitoku; Kohi, the great teacher of Tannyu; Yuwasa Katsushige, the so-called

father of the Ukiyoe School; and Itcho, noted for his panegyrics on the life of the day, were all artists of rank in the highest line—yet they delighted to paint the common scenes of life, with no feeling of lowering themselves, such as high-class artists of the later Tokugawa had, and so this age of revelry and pleasure led to the creation of a great decorative, though not a spiritual art. The only school which stands out with deep significance is that of Sotatsu and Korin. Their pioneers, Koyetsu and Koho, drew from the dêbris of the decadent and almost lost school of the Tosa, and tried to infuse into it the bold conceptions of the Ashikaga masters. True to the instinct of the period, they expressed themselves in rich colouring. They handled colour more as mass than as line, as former colourists had done, and would bring out with a simple wash the broadest effect. Sotatsu gives us best of all the spirit of Ashikaga in its purity, while Korin, through his very ripeness, degenerates into formalism and posing.

We find in Korin's life a pathetic story of his sitting on a brocade cushion whenever he painted a picture, saying, "I must feel like a daimyo while I create!" showing that a touch of class distinction was beginning to creep into the artistic mind even then.

This school, foreshadowing modern French Impressionism by two centuries, was nipped in the bud of its great futurity by that icy conventionalism of the Tokugawa régime to which it unfortunately succumbed.

Later Tokugawa Period

1700–1850 A.D.

The Tokugawas, in their eagerness for consolidation and discipline, crushed out the vital spark from art and life. It was only their educational institutions which in later days reached the lower classes, and to some slight extent redeemed these defects.

In their prime of power, the whole of society—and art was not exempt—was cast in a single mould. The spirit which secluded Japan from all foreign intercourse, and regulated every daily routine, from that of the daimyo to that of the lowest peasant, narrowed and cramped artistic creativeness also.

The Kano academies—filled with the disciplinary instincts of Iyeyasu—of which four were under the direct patronage of the Shoguns and sixteen under the Tokugawa government, were constituted on the plan of regular feudal tenures. Each academy had its hereditary lord, who followed his profession, and, whether or not he was an indifferent artist, had under him students who flocked from various parts of the country, and who were, in their turn, official painters to different daimyos in the provinces. After graduating at Yedo (Tokyo), it was *de rigueur*

for these students, returning to the country, to conduct their work there on the methods and according to the models given them during instruction. The students who were not vassals of daimyos were, in a sense, hereditary fiefs of the Kano lords. Each had to pursue the course of studies laid down by Tannyu and Tsunenobu, and each painted and drew certain subjects in a certain manner. From this routine, departure meant ostracism, which would reduce the artist to the position of a common craftsman, for he would not in that case be allowed to retain the distinction of wearing two swords. Such a condition of things could not but be detrimental to originality and excellence.

Besides the Kanos, the house of Tosa, with its younger branch, Sumiyoshi, was re-established with hereditary honours at the beginning of the Tokugawa rule, but the Tosa inspiration and tradition had been lost ever since the days of Mitsunobu, who had clung heroically to his old school during the Ashikaga period. In thus standing out against the national stream, he had shown a weakness, it is true. Yet we must not forget that, when all other artists were painting in ink, he had still maintained the glorious tradition of colour. The new Tosa School, however, imitated only the mannerisms of their ancestors, and any vitality which they threw into this was reflected from the work of the Kanos, as the pictures of Mitsuoki and Gukei show.

The sordid aristocracy of the day looked upon all this as natural, for their own lives were regulated on the same basis. The son would order a picture from a contemporary Kano or Tosa as his father had done from the preceding academician. Meanwhile, the life of the people was entirely apart. Their loves and aspirations were utterly different, though their round of existence was equally stereotyped. Forbidden the high honours of the court and intercourse with aristocratic society, they sought their freedom in

mundane pleasures, in the theatre, or in the gay life of Yoshiwara. And as their literature forms another world from that of the writings of the Samurai, so their art expresses itself in the delineation of gay life and in the illustration of theatrical celebrities.

The Popular School, which was their only expression, though it attained skill in colour and drawing, lacks that ideality which is the basis of Japanese art. Those charmingly coloured woodcuts, full of vigour and versatility, made by Outamaro, Shunman, Kionobu, Harunobu, Kionaga, Toyokuni, and Hokusai, stand apart from the main line of development of Japanese art, whose evolution has been continuous ever since the Nara period. The inros, the netsukes, the sword-guards, and the delightful lacquer-work articles of the period, were playthings, and as such no embodiment of national fervour, in which all true art exists. Great art is that before which we long to die. But the art of the late Tokugawa period only allowed a man to dwell in the delights of fancy. It is because the prettiness of the works of this period first came to notice, instead of the grandeur of the masterpieces hidden in the daimyos' collections and the temple treasures, that Japanese art is not yet seriously considered in the West.

The bourgeois art of Yedo (Tokyo), under the dread shadow of the Shoguns, was limited thus to a narrow round of expression. It was due to the freer atmosphere of Kyoto that another and higher form of democratic art was evolved. Kyoto, where the imperial seat remained, was on that account comparatively free from the Tokugawa discipline, for the Shoguns dared not assert themselves here as openly as in Yedo and in other parts of the country. Here it was, therefore, that scholars and free-thinkers flocked to take refuge, so making it, a century and a half later, the fulcrum on which would turn the lever of the Meiji restoration. It was here that artists who disdained the Kano yoke could

venture to indulge in wilful deviations from tradition, here that the rich middle classes could permit themselves to admire their originality. Here was Busson trying to formulate a new style by illustrating the popular poetry; here was Watanabe-Shiko, who tried to revive Korin's style, and Shohaku, who, with Blake-like instinct, revelled in wild imagery based on Jasoku of the Ashikaga period; and here, finally, was Jakuchu, a fanatic, who loved to paint impossible birds.

Kyoto, however, had two real influences. First was the introduction and revival of the later Ming (1368-1662) and earlier Manchu-Shin style, which had been inaugurated in China by dilettantes and æsthetes, who considered a painting to he worth-less when it came from the hands of a professional, and prized the playful sketches of a great scholar above the works of a master-artist. In its own way, even this must be understood as a demonstration of the immense power of the Chinese mind in breaking away from the formalism of the Gen academic style imposed during the Mongol dynasty. Artists from Kyoto crowded to Nagasaki, the one port then open, to study from Chinese traders this new style, already hardened into manner-ism before it reached Japan.

The second important effort of Kyoto was the study which it initiated of European realistic art. Matteo-Ricci had been a Roman Catholic missionary, who had entered China during the Ming dynasty, and given the impulse which had now made the new school of Realism prominent in the cities at the mouth of the Yang-tse. Chinnan-ping, a Chinese artist of this school who was noted for his birds and flowers, resided in Nagasaki for three years, and laid the foundation of the Natural School of Kyoto.

Dutch prints were eagerly sought and copied, and Maruyama Okio, the founder of the Maruyama School, devoted himself in

his youth to copying them. It is pathetic to note that he copied the lines of the engravings with his brush. It was due to this artist that the movement was brought to a focus, for he, with an early Kano training, was able to combine the new methods with a style of his own. He was an ardent student of nature, serving her moods in all their detail, and his delicacy and softness and exquisite gradation of effects on silk give him his right to be called the representative artist of this period.

Goshun, his rival, the founder of the Shijo School, follows closely in his steps, though his Chinese mannerisms of later Ming differentiate him.

Ganku, another realist, ancestor of the Kisshi School, differs from the first two by his closer similarity to Chinnan-ping.

These three streams of tendency together constitute the modern Kyoto School of Realism. They sound a different note from the Kanos, yet, with all their dexterity and skill, they also fail to catch the truly national element in art, as their brethren in Yedo failed to do in the Popular School. Their works are delightful and full of grace, but never grasp the essential character of the subject as Sesshu and other artists used to do. The occasions when Okio rises to great heights are when he reverts unconsciously to those methods which governed the old masters.

Kyoto art, since the death of these three great workers, consists only of attempts by their followers to combine in different proportions the individual excellence of their respective styles. Yet, up to the rise of contemporary Japanese art, in the second decade of the Meiji restoration in 1881, the Kyoto artists were the leading creative spirits in pictorial art.

Notes

Kano Academies.—These owe their name to a family of artists who were appointed painters-in-ordinary to the Tokugawas.

Inros.—Small lacquer medicine-cases, to be hung on the obi or girdle.

Netsukis.—Ornamental buttons by which the inro or the tobacco-pouch was hung.

The Meiji Period

1850 to the present day

T he Meiji period begins formally with the accession in 1868 of the present Emperor, under whose august direction a new ordeal, unlike any in the annals of our country, has had to be faced.

That constant play of colour which distinguishes the religious and artistic life of the nation, as we have described it in the preceding pages—now gleaming in the amber twilight of idealistic Nara, now glowing with the crimson autumn of Fujiwara, again losing itself in the green sea waves of Kamakura, or shimmering in the silver moonshine of Ashikaga—returns upon us here in all its glory, like the fresh verdure of a rain-swept summer. Yet the vicissitudes of this new age, whose thirty-four years have passed, bringing each moment some new and greater programme, surround us with a labyrinth of contradictions, amongst which it becomes extremely difficult to abstract and unify the underlying idea.

And indeed the critic who speaks of contemporary art is always in danger of treading merely on his own shadow, lingering in wonder over those gigantic, or may be grotesque, figures which the slanting rays of sunset cast on the ground

behind him. There are to-day two mighty chains of forces which enthral the Japanese mind, entwining dragon-like upon their own coils, each struggling to become sole master of the jewel of life, both lost now and again in an ocean of ferment. One is the Asiatic ideal, replete with grand visions of the universal sweeping through the concrete and particular, and the other European science, with her organised culture, armed in all its array of differentiated knowledge, and keen with the edge of competitive energy.

The two rival movements awoke to consciousness almost simultaneously, a century and a half ago. The first began in an attempt to recall Japan to a sense of that unity which the various waves of Chinese and Indian culture—however much colour and strength they might bring—had tended to obscure.

Japanese national life is centred in the throne, over which broods in transcendent purity the glory of a succession unbroken from eternity. But our curious isolation and long-standing lack of foreign intercourse had deprived us of all occasion for self-recognition. And in politics the vision of our sacred organic unity had been somewhat screened by the succession of the Fujiwara aristocracy, giving place in turn to the military dictatorship of the Shogunate under the Minamotos, the Ashikagas, and the Tokugawas.

Amongst the various causes which contributed to arouse us from this torpor of centuries may be mentioned, *firstly, the Confucian revival of the Ming scholars, as reflected in the learning of the early Tokugawa period*. The first Emperor of Ming who overthrew the Mongol dynasty in China was himself a Buddhist monk. Yet he considered the Neo-Confucianism of the Sung scholars—with its individualism based on Indian ideas—as dangerous to the unification of a grand Empire. He therefore discouraged this Neo-Confucianism, and sought also to sweep

away the maze of Thibetan Tantrikism which the Mongols had brought to China, before attempting the regeneration of the native political supremacy. Since Neo-Confucianism is Confucianism under Buddhist interpretation, this means that the Emperor tried to revert to pure Confucianism. Thus the Ming scholars returned to the Hâng commentators, and an age of archaeological research was begun which attained its culmination in the gigantic works of the present Manchu dynasty under Kanhi and Kenliu.

Japanese scholarship, following this great precedent, turned its gaze backwards over its ancient history. Fine historical works appeared written in Chinese, amongst them *Dainihonshi*, or "The History of Mighty Japan," compiled by the order of Prince Mito, two hundred years ago. Such books gave expression to a passionate worship of those heroic personifications of loyalty who had perished, like Masashige, in glorious self-sacrifice, at the close of the Kamakura period, and the reader was already stirred to long for the revindication of the imperial power.

A significant dialogue of this period is that in which an eminent scholar, noted for his reverence towards the Indian and Chinese sages, was asked by an antagonist, "What would you do—you with your overpowering love for these great masters—if an army were to invade Japan, with Buddha as its generalissimo, and Confucius as his lieutenant?" He answered without hesitation, "Strike off the head of Sakya-Muni, and steep the flesh of Confucius in brine!"

It was this torch that burned in the hand of Sannyo, when he, a century later, wrought out that epic narrative of the country from whose poetic pages the youth of Japan still learn the intensity of the raging fever that moved their grandfathers to the revolution.

A study of purely Japanese ancient literature came into vogue, led by the master-minds of Motoori and Harumi, to whose colossal works on grammar and philology modern scholars find little to add.

This led very naturally to the revival of Shintoism, that pure form of ancestor-worship extant in Japan before Buddhism, but covered long since, especially by the genius of Kukai, with Buddhist interpretations. This element in the national religion centres always in the person of the Emperor, as the descendant of the Godhead. Its revival, therefore, must always mean an accession of patriotic self-consciousness.

The Buddhistic sects, weakened as they had been by the peaceful and worldly attitude of the Shogunate, which had granted them hereditary privileges, were quite unable to assimilate this awakened energy of Shintoism, and to this fact we owe the sad destruction and scattering of the treasures of the Buddhist temples and monasteries, when the monks and priests were forced to turn Shinto by threats of instant annihilation. Indeed the zeal of the new converts themselves often added the torch of destruction to this funeral pyre of forced conversion.

The second cause of the national reawakening was undoubtedly that portentous danger with which Western encroachments on Asiatic soil threatened our national independence. Through the Dutch merchants who kept us informed of the current events of the outside world, we knew of the mighty arm of conquest which Europe extended towards the East.

We saw India, the holy land of our most sacred memories, losing her independence through her political apathy, lack of organisation, and the petty jealousies of rival interests—a sad lesson, which made us keenly alive to the necessity of unity at any cost. The opium war in China, and the gradual succumbing

of Eastern nations, one by one, to the subtle magical force which the black ships brought over the seas, brought back the dread image of the Tartar Armada, calling women to pray and men to polish their swords, now groaning in the rust of three centuries of peace. There is a short but significant sonnet by Komeitenno— the august father of the present Majesty, to whose far-sighted penetration Japan owes much of her modern greatness—which says, "To the utmost of thy soul's power do thy best. Then kneel alone, and pray for the divine wind of Isé, that drove back the Tartar fleet," full of the self-reliant manhood of the nation. The beautiful bells of temples, accustomed to vibrate the music of repose and love, were torn from their time-honoured belfries to cast the cannon to defend the coasts. Women flung their mirrors into the same burning furnace, seething with patriotic fire. Yet the powerful holders of the ropes at the helm of the state were well aware of the dangers which awaited the country, were it plunged rashly or unequipped into warlike defiance of the so-called Western barbarians. It was their part to struggle and stem slowly the maddening torrent of Samurai enthusiasm, while attempting nevertheless to open the country. to Western inter-course. Many, like Iikamon, sacrificed their lives in the declaration that the nation was not ready for fool-hardy self-assertion. Lasting gratitude is due to these, as well as to the armed embassy of America, whose national policy opened our doors in a spirit of enlightenment that was not self-aggrandisement.

Another and third impetus was given by the southern daimyos, who, as descendants of the aristocracy of Hideyoshi and com-rades of Iyeyasu, had been constantly fretted by the absolutism of the Tokugawa Shogunate, which had almost reduced them to the position of hereditary vassals. The princes of Satsuma and of Choshu, of Hizen and of Tosa, had always kept alive the sense of

their past grandeur, and had afforded shelter to the refugees who escaped to them from the wrath of the court of Yedo. It was in their territories, therefore, that the new spirit of revolution could breathe with freedom. It was in their territories that the mighty statesmen who rebuilt the new Japan were born; to the lands within their bounds that the great spirits who rule her to the present day must trace their lineage. These strong clans furnished the generals and soldiers who overturned the Shogunate, though honour is due also to the princely house of Mito and to Echizen of the Shogunate itself, who united to bring a speedy peace to the Empire, and to make that great renunciation in which all the daimyos and Samurai joined, sacrificing their time-honoured fiefs to the throne, and becoming equal before the law, as fellow-citizens with the meanest peasant in the land.

So the Meiji restoration glows with the fire of Patriotism, a great rebirth of the national religion of loyalty, with the transfig-ured halo of the Mikado in the centre. The educational system of the Tokugawas, which had spread the knowledge of reading and writing to all boys and girls alike, studying in the village schools under the resident village priests, had laid the foundation of that compulsory elementary education which was amongst the first acts of the present reign. Thus high and low became one in the great new energy that thrilled the nation, making the humblest conscript in the army glory in death, like a Samurai.

In spite of political squabbles—natural-unnatural children of a constitutional system such as was freely bestowed by the monarch in 1892—a word from the throne will still conciliate the Government and Opposition, hushing both to mute rever-ence, even during their most violent dissensions.

The Code of Morality, the keystone of Japanese ethics as taught in the schools, was given by an imperial mandate, when

all other suggestions failed to strike the note of that all-embracing veneration that was needed.

On the other hand, the wonders of modern science, since more than a century ago, had been dawning on the amazed minds of the students at Nagasaki, the only port where the Dutch traders came. The knowledge of geography which they gleaned from this source opened out new vistas of humanity. Western medicine and botany were studied at first under the greatest difficulties. European methods of warfare, which the Samurai naturally wished to acquire, led them into serious dangers, as the Shogunate considered all such attempts to be directed against their supremacy. It is heart-rending to read the history of those pioneers of Western science, who devoted themselves in secrecy to deciphering the Dutch lexicon, even as archæologists unravelled the mysteries of ancient civilisations, through the Rosetta Stone.

The memory of the Jesuit encroachment of the seventeenth century, ending in the terrible massacre of the Christian population of Shimabara, had brought about the prohibition against building seafaring vessels above a certain tonnage, and caused the penalty of death to threaten any one who, not being an official appointed to treat with the Hollanders, might dare to hold communication with foreigners. This shut off the Western world, as though behind an iron wall, so that it required the greatest self-sacrifice and heroism to make the adventurous youth seek passage in those stray European vessels which chanced now and then to touch our coasts.

But the thirst for knowledge was not to be quenched. The task of preparing for the civil war which was to engage the rival powers of the Shogunate and the southern daimyos gave occasion for the introduction of French officers, instigated as this

was by the ambition of the French in their scheme for checking the Asiatic expansion of the English.

The advent of the American Commodore Perry finally opened the flood-gates of Western knowledge, which burst over the country so as almost to sweep away the landmarks of its history. At this moment Japan, in the re-awakened consciousness of her national life, was eager to clothe herself in new garb, discarding the raiment of her ancient past. To cut away those fetters of Chinese and Indian culture which bound her in the maya of Orientalism, so dangerous to national independence, seemed like a paramount duty to the organisers of the new Japan. Not only in their armaments, industry, and science, but also in philosophy and religion, they sought the new ideals of the West, blazing as that was with a wonderful lustre to their inexperienced eyes, as yet indiscriminating of its lights and shadows. Christianity was embraced with the same enthusiasm which welcomed the steam engine; the Western costume was adopted as they adopted the machine gun. Political theories and social reforms, worn out in the land of their birth, were hailed here with the same new delight with which they took to the stale and old-fashioned goods of Manchester.

The voices of great statesmen like Iwakura and Okubo were not slow to condemn the wholesale ravages which this frenzied love of European institutions was committing on the ancient customs of the country. But even they considered no sacrifice too great if the nation were to be made efficient for the new contest. Thus modern Japan holds a unique position in history, having solved a problem not comparable perhaps to any, save that which faced the vigorous activity of the Italian mind in the fifteenth and sixteenth centuries. For at that point in its development the West also had to grapple with the double task of assimilating, on

the one hand the Greco-Roman culture precipitated upon it by the rise of the Ottoman Turks, and on the other the new spirit of science and liberalism which, in the discovery of a new world, the birth of a reformed faith, and the rise of the idea of liberty, was helping to uplift from it the cloud of mediævalism. And this twofold assimilation it was that constituted the Renaissance.

Like the great days of the small Italian Republics, when each struggled to find a new solution of life, and burst to the surface only to be swept away by the winds of contention, so this Meiji era, foaming with its bubbles of would-be assertiveness, teems with an unparalleled interest for the world, though tinged at once by the pathetic and the ridiculous.

The wild whirlpool of individualism, seeking ever to make its own stormy will its law, now rending the skies in its agonies of destruction, again lashing itself into furious welcome of any new scrap of Western religion and polity, would have dashed the nation to pieces in its seething turmoil, had not the solid rock of adamantine loyalty formed its immovable base. The strange tenacity of the race, nurtured in the shadow of a sovereignty unbroken from its beginning, that very tenacity which preserves the Chinese and Indian ideals in all their purity amongst us, even where they were long since cast away by the hands that created them, that tenacity which delights in the delicacy of Fujiwara culture, and revels at the same time in the martial ardour of Kamakura, which tolerates the gorgeous pageantry of Toyotomi, even while it loves the austere purity of the Ashikagas, holds Japan to-day intact, in spite of this sudden incomprehensible influx of Western ideas. To remain true to herself, notwithstanding the new colour which the life of a modern nation forces her to assume, is, naturally, the fundamental imperative of that Adwaita idea to which she was trained by

her ancestors. To the instinctive eclecticism of Eastern culture she owes the maturity of judgment which made her select from various sources those elements of contemporary European civilisation that she required. The Chinese War, which revealed our supremacy in the Eastern waters, and which has yet drawn us closer than ever in mutual friendship, was a natural outgrowth of the new national vigour, which has been working to express itself for a century and a half. It had also been foreseen in all its bearings by the remarkable insight of the older statesmen of the period, and arouses us now to the grand problems and responsibilities which await us as the new Asiatic Power. Not only to return to our own past ideals, but also to feel and revivify the dormant life of the old Asiatic unity, becomes our mission. The sad problems of Western society turn us to seek a higher solution in Indian religion and Chinese ethics. The very trend of Europe itself, in German philosophy and Russian spirituality, in its latest developments, towards the East, assists us in the recovery of those subtler and nobler visions of human life which drew these nations themselves nearer to the stars in the night of their material oblivion.

The double nature of the Meiji restoration is manifest in the field of art, which is struggling, like the political consciousness, to attain its higher rounds. The spirit of historical inquiry and the revival of ancient letters led art back to the pre-Tokugawa schools, transcending the popular democratic notion of the Ukioye, and returning at once to the methods of the Tosas in the heroic Kamakura period. Historical painting, enriched in material by the archæological research of the scholars, became the vogue. Tameyasu and To-tsugen were the pioneers of this Kamakura revival, which laid its hand upon the naturalistic school of Kyoto through the works of Yosai, and was even

reflected by the popular brush of Hokusai. A parallel movement occurred at the same time in fiction and the drama.

The downfall of the sanctity of Buddhist monasteries and the dispersion of the daimyos' treasures, through that apathy to art which considered it as a luxury, fatal in a moment of supreme patriotic sacrifice, opened the artistic mind to a hitherto unknown side of ancient art, just as Greco-Roman masterpieces were revealed to the early Italians of the Renaissance. Thus the first reconstructive movement of the Meiji period was the preservation and imitation of the ancient masters, led by the Bijitsu Kyo-Kai Art Association. This society, made up of the aristocracy and connoisseurs, opened annual exhibitions of old *chefs-d'œuvres*, and conducted competitive salons in a spirit of conservatism which naturally drops by degrees into formalism and meaningless reiteration. On the other hand, that study of Western realistic art which had slowly gained ground under the late Tokugawa, a study in which the attempts of Shibakokan and Ayodo are conspicuous, now found an opportunity for unrestricted growth. That eagerness and profound admiration for Western knowledge which confounded beauty with science, and culture with industry, did not hesitate to welcome the meanest chromos as specimens of great art ideals.

The art which reached us was European at its lowest ebb—before the *fin-de-siècle* æstheticism had redeemed its atrocities, before Delacroix had uplifted the veil of hardened academic chiaro-oscuro, before Millet and the Barbizons brought their message of light and colour, before Ruskin had interpreted the purity of pre-Raphaelite nobleness. Thus the Japanese attempt at Western imitation which was inaugurated in the Government School of Art—where Italian teachers were appointed to teach—grovelled in darkness from its infancy, and yet succeeded, even at

its inception, in imposing that hard crust of mannerism which
impedes its progress to the present day. But the active individu-
alism of Meiji, teeming with life in other cycles of thought, could
not be content to move in those fixed grooves which orthodox
conservatism or radical Europeanisation imposed on art. When
the first decade of the era was passed, and recovery from the
effects of civil war was more or less complete, a band of earnest
workers strove to found a third belt of art-expression, which, by
a higher realisation of the possibilities of ancient Japanese art,
and aiming at a love and knowledge of the most sympathetic
movements in Western art-creations, tried to reconstruct the
national art on a new basis, whose keynote should be "Life
true to Self." This movement resulted in the establishment of
a Government Art School at Ueno, Tokyo, and, since the dis-
integration of the faculty in 1897, is represented by the Nippon
Bijitsuin at Yanaka, in the suburbs of the city, whose biennial
exhibitions reveal, it is hoped, the vital element in the contem-
porary art activity of the country.

According to this school, freedom is the greatest privilege of
an artist, but freedom always in the sense of evolutional self-
development. Art is neither the ideal nor the real. Imitation,
whether of nature, of the old masters, or above all of self, is
suicidal to the realisation of individuality, which rejoices always
to play an original part, be it of tragedy or comedy, in the grand
drama of life, of man, and of nature.

To this school, again, the old art of Asia is more valid than
that of any modern school, inasmuch as the process of idealism,
and not of imitation, is the *raison d'être* of the art-impulse. The
stream of ideas is the real: facts are mere incidents. Not the
thing as it was, but the infinitude it suggested to him. is what
we demand of the artist. It follows that the feeling for line,

chiaro-oscuro as beauty, and colour as the embodiment of emotion, are regarded as strength, and that to every criticism of the naturalesque, the search after beauty, the demonstration of the ideal, is deemed a sufficient answer.

Fragments of nature in her decorative aspects; clouds black with sleeping thunder; the mighty silence of pine forests; the immovable serenity of the sword; the ethereal purity of the lotus rising out of darkened waters; the breath of star-like plum flowers; the stains of heroic blood on the robes of maidenhood; the tears that may be shed in his old age by the hero; the mingled terror and pathos of war; or the waning light of some great splendour—such are the moods and symbols into which the artistic consciousness sinks, before it touches with revealing hands that mask under which the universal hides.

Art thus becomes the moment's repose of religion, or the instant when love stops, half-unconscious, on her pilgrimage in search of the Infinite, lingering to gaze on the accomplished past and dimly-seen future—a dream of suggestion, nothing more fixed—but a suggestion of the spirit, nothing less noble.

Technique is thus but the weapon of the artistic warfare; scientific knowledge of anatomy and perspective, the commissariat that sustains the army. These Japanese art may safely accept from the West, without detracting from its own nature. Ideals, in turn, are the modes in which the artistic mind moves, a plan of campaign which the nature of the country imposes on war. Within and behind them lies always the sovereign-general, immovable and self-contained, nodding peace or destruction from his brow.

Both the range of subjects and the method of their expression grow wider under this new conception of artistic freedom. The lamented Kano Hogai, Hashimoto Gaho, the greatest living

master of the age, and the numerous geniuses who follow in their track, are not only noted for their versatility of technique, but for their enlarged notion of the subject-matter of art. These two masters, themselves renowned professors of the chief Kano academy at the close of the Shogunate, inaugurated the revival of the Ashikaga and Sung masters in their ancient purity, together with the study of Tosa and the Korin colourists, without at the same time losing the delicate naturalism of the Kyoto School.

The ancient spirit of race-myths and historic chronicles has breathed upon these painters, as at every great epoch of revival in art, from the time of Æschylus to that of Wagner and the Northern European poets, and their pictures give new fire and meaning to these great themes.

The last masterpiece of Kano Hogai represents Kwannon, the Universal Mother, in her aspect of human maternity. She stands in mid-air, her triple halo lost in the sky of golden purity, and holds in her hand a crystal vase, out of which is dropping the water of creation. A single drop, as it falls, becomes a babe, which, wrapped in its birth-mantle like a nimbus, lifts unconscious eyes to her, as it is wafted downwards to the rugged snow-peaks of the earth rising from a mist of blue darkness far below. In this picture a power of colour like that of the Fujiwara epoch joins with the grace of Maruyama, to afford expression to an interpretation of nature as mystic and reverent as it is passionate and realistic.

Gaho's picture of Chokaro combines the strong style of Sesshu with the broad massing of Sotatsu. It takes up and re-expresses the obsolete Taoist idea, of the magician who watches with wistful smiles the donkey that he has just projected from his gourd, an image of the playful attitude of fatalism.

Kanzan's "Funeral Pyre of Buddha" recalls to us the grand composition of the Heian period, enriched by the strongly accentuated outlines of the early Sung, and a modelling equal to the Italian artists. It represents the great Arhats and Boddhi-Sattvas around the burning pyre watching with mysterious awe the ethereal flame which breaks over that mystic coffin, destined one day to—fill the world with its light of supreme renunciation.

Taikan brings into the field his wild imagery and tempestuous conceptions, as shown in his "Kutsugen Wandering on the Barren Hills" amongst wind-blown narcissus—the flower of silent purity—feeling the raging storm that gathers in his soul.

The epic heroes of Kamakura are painted to-day with a deeper insight into human nature. Mythology is interpreted in its solar significance, and the ancient ballads also, both of China and Japan, open up to us an area hitherto unexplored.

Sculpture and other arts follow closely on this road. The wonderful glaze of Kozan is not only reviving the lost secrets of early Chinese ceramics, but creating new Korin-like dreams in colour.

Lacquer is emancipated from the delicate finesse of the later Tokugawas, and loves to revel in a wider range of colour and materials, and the sister-arts of embroidery and tapestry, of cloisonné and metal-work, are breathing new life throughout their wide domains. Thus art, in spite of its new conditions of patronage and the dreadful grind of mechanical industry, is striving to attain to a higher life, which shall express the contemporary vitality of our national aspirations. But the time is not yet ripe for an exhaustive summary. Each day opens up fresh elements of possibility and hope, calling out for a place in the scheme of reawakened nationalisation. China and India, not to speak of

the artistic activity of the West, which is also struggling for a new expression, present their grand ideal vistas, yet to be trodden by the explorers of the future.

Notes

Sannyo.—Writer of the Nippon-Gaishi and the Nippon-Seiki, and noted also for his poems on historical and patriotic subjects. He lived at the beginning of the nineteenth century, and spent many years in wandering about the country in search of the materials for his history, which were rendered difficult to obtain by the eagerness of the Tokugawas to suppress the national consciousness.

Adwaita idea.—The word *adwaita* means the state of not being two, and is the name applied to the great Indian doctrine that all which exists, though apparently manifold, is really one. Hence all truth must be discoverable in any single differentiation, the whole universe involved in every detail. All thus becomes equally precious.

The Vista

The simple life of Asia need fear no shaming from that sharp contrast with Europe in which steam and electricity have placed it to-day. The old world of trade, the world of the craftsman and the pedlar, of the village market and the saints'-day fair, where little boats row up and down great rivers laden with the produce of the country, where every palace has some court in which the travelling merchant may display his stuffs and jewels for beautiful screened women to see and buy, is not yet quite dead. And, however its form may change, only at a great loss can Asia permit its spirit to die, since the whole of that industrial and decorative art which is the heirloom of ages has been in its keeping, and she must lose with it not only the beauty of things, but the joy of the worker, his individuality of vision, and the whole age-long humanising of her labour. For to clothe oneself in the web of one's own weaving is to house oneself in one's own house, to create for the spirit its own sphere.

Asia knows, it is true, nothing of the fierce joys of a time-devouring locomotion, but she has still the far deeper travel-culture of the pilgrimage and the wandering monk. For the Indian ascetic, begging his bread of village housewives, or seated at evenfall beneath some tree, chatting and smoking with the

peasant of the district, is the real traveller. To him a countryside does not consist of its natural features alone. It is a nexus of habits and associations, Of human elements and traditions, suffused with the tenderness and friendship of one who has shared, if only for a moment, the joys and sorrows of its personal drama. The Japanese peasant-traveller, again, goes from no place of interest on his wanderings without leaving his *hokku* or short sonnet, an art-form within reach of the simplest.

Through such modes of experience is cultivated the Eastern conception of individuality as the ripe and living knowledge, the harmonised thought and feeling of staunch yet gentle manhood. Through such modes of interchange is maintained the Eastern notion of human intercourse, not the printed index, as the true means of culture.

The chain of antitheses might be indefinitely lengthened. But the glory of Asia is something more positive than these. It lies in that vibration of peace that beats in every heart; that harmony that brings together emperor and peasant; that sublime intuition of oneness which commands all sympathy, all courtesy, to be its fruits, making Takakura, Emperor of Japan, remove his sleeping-robes on a winter night, because the frost lay cold on the hearths of his poor; or Taiso, of Tâng, forego food, because his people were feeling the pinch of famine. It lies in the dream of renunciation that pictures the Boddhi-Sattva as refraining from Nirvana till the last atom of dust in the universe shall have passed in before to bliss. It lies in that worship of Freedom which casts around poverty the halo of greatness, imposes his stern simplicity of apparel on the Indian prince, and sets up in China a throne whose imperial occupant—alone amongst the great secular rulers of the world—never wears a sword.

These things are the secret energy of the thought, the science, the poetry, and the art of Asia. Torn from their tradition, India, made barren of that religious life which is the essence of her nationality, would become a worshipper of the mean, the false, and the new; China, hurled upon the problems of a material instead of a moral civilisation, would writhe in the death-agony of that ancient dignity and ethics which long ago made the word of her merchants like the legal bond of the West, the name of her peasants a synonym for prosperity; and Japan, the Fatherland of the race of Ama, would betray the completeness of her undoing in the tarnishing of the purity of the spiritual mirror, the bemeaning of the sword-soul from steel to lead. The task of Asia to-day, then, becomes that of protecting and restoring Asiatic modes. But to do this she must herself first recognise and develop consciousness of those modes. For the shadows of the past are the promise of the future. No tree can be greater than the power that is in the seed. Life lies ever in the return to self. How many of the Evangels have uttered this truth! "Know thyself," was the greatest mystery spoken by the Delphic Oracle. "All in thyself," said the quiet voice of Confucius. And more striking still is the Indian story that carries the same message to its hearers. For once it happened, say the Buddhists, that, the Master having gathered his disciples round him, there shone forth before them suddenly—blasting the sight of all save Vajrapani, the completely-learned—a terrible figure, the figure of Siva, the Great God. Then Vajrapani, his companions being blinded, turned to the Master and said, "Tell me why, searching amongst all the stars and gods, equal in number to the sands of the Ganges, I have nowhere seen this glorious form. Who is he?" And the Buddha said, "He is thyself!" and Vajrapani, it is told, immediately attained the highest.

It was some small degree of this self-recognition that re-made Japan, and enabled her to weather the storm under which so much of the Oriental world went down. And it must be a renewal of the same self-consciousness that shall build up Asia again into her ancient steadfastness and strength. The very times are bewildered by the manifoldness of the possibilities opening out before them. Even Japan cannot, in the tangled skein of the Meiji period, find that single thread which will give her the clue to her own future. Her past has been clear and continuous as a mala, a rosary, of crystals. From the early days of the Asuka period, when the national destiny was first bestowed, as the receiver and concentrator, by her Yamato genius, of Indian ideals and Chinese ethics; through the succeeding preliminary phases of Nara and Heian, to the revelation of her vast powers in the unmeasured devotion of her Fujiwara period, in her heroic reaction of Kamakura, culminating in the stern enthusiasm and lofty abstinence of that Ashikaga knighthood who sought with so austere a passion after death—through all these phases the evolution of the nation is clear and unconfused, like that of a single personality. Even through Toyotomi, and Tokugawa, it is clear that after the fashion of the East we are ending a rhythm of activity with the lull of the democratising of the great ideals. The populace and the lower classes, notwithstanding their seeming quiescence and commonplaceness, are making their own the consecration of the Samurai, the sadness of the poet, the divine self-sacrifice of the saint-are becoming liberated, in fact, into their national inheritance.

But to-day the great mass of Western thought perplexes us. The mirror of Yamato is clouded, as we say. With the Revolution, Japan, it is true, returns upon her past, seeking there for the new vitality she needs. Like all genuine restorations, it is a reaction

with a difference. For that self-dedication of art to nature which the Ashikaga inaugurated has become now a consecration to the race, to man himself. We know instinctively that in our history lies the secret of our future, and we grope with a blind intensity to find the clue. But if the thought be true, if there be indeed any spring of renewal hidden in our past, we must admit that it needs at this moment some mighty reinforcement, for the scorching drought of modern vulgarity is parching the throat of life and art.

We await the flashing sword of the lightning which shall cleave the darkness. For the terrible hush must be broken, and the raindrops of a new vigour must refresh the earth before new flowers can spring up to cover it with their bloom. But it must be from Asia herself, along the ancient roadways of the race, that the great voice shall be heard.

Victory from within, or a mighty death without.

Chronology of Asian Art

Chinese Dynasty	Japan and the East	The West
BC 6c Shin	Confucianism (by Confucius), *Ch.* Laoism (by Laotse), *Ch.* Taoism (by Soshi), *Ch.* Poetry by Kutsugen, *Ch.*	Greek and Roman architecture
Hang	The 1st stage of Buddhism, after the Nirvana, *Ind.* King Asoka, *Ind.*	Conquest of Gaul (by Caesar) Birth of Jesus Christ
AD 3c The Three Kingdoms	Mahabharata, the epic of "Great India," *Ind.* The first wooden pagoda	Old and New Testament
	The 2nd staage of Buddhism, *Ind.* **Wall paintings of Ajanta** **Sculptures of the Ellora caves**	
4c The Six Dynasties	*THE ASUKA PERIOD* Introduction of Buddhism **Rock-cut images of Riumonsan near Loyang,** *Ch.* The 3rd stage of Buddhism, *Ind.* Mathematics and astronomy, *Ind.* Poetry by Kalidasa, *Ind.*	Fall of the Western Roman Empire
7c	**Seventeen Articles of the** Japanese Constitution (by Prince Wumayado a.k.a. Shotoku-Taishi with Empress Suiko)	Birth of Muhammad

Chinese Dynasty	Japan and the East	The West
7c Tâng (618 to 907 A.D.)	Colossal bronze of Ankoin, Asuka Temple Horinji Temple, incl. the Sakya trinity in Kondo (Golden Hall) the Yakushi Trinity, Kwannon of Yumedono Wooden Kwannon of Chuguji Empress Suiko's Shrine	Christianity introduced to Britain Island
	THE NARA PERIOD Algebra and astronomy, *Ind.* Gensho (Hiouen-Tsang) and Gijo (Iching) visited India, *Ch.* The Japanese alphabet created New Buddhist sects founded;	Beowulf, *Eng.*
8c	Hosso sect, Kegon sect. *Ch.* Roshana of Riumonsan, *Ch.* Roshana Buddha of stone in Yangtse, *Ch.*	
	New Capital of the Yamato, founded by Emperor Tenji to become the Buddhist centre (present town of Nara) China Confucians, Taoists, Buddhists, Nestorian fathers, Zoroastrians Bronze trinity of Amida and and Yakushi trinity in Yakushiji Kwannon of Toindo Sakya of Kanimanji Roshana Buddha of Nara Colossal Kwannon of Sangatsudo The imperial collection, incl. the biwa, in the Imperial treasure-house (Shosoin)	

Chinese Dynasty	Japan and the East	The West
8c Tâng (618 to 907 A.D.)	*THE HEIAN PERIOD* The Mikkio (Esoteric doctrine) Yoga introduced to China Seven Patriarchs of the Sect of theTrue World (painting by Kukai) Yakshi Buddha, the Great Healer in the Zhingoji temple (sculpture by Kukai) Eleven-Headed Kwannon of Toganji, Omi (sculpture by Saicho) Nioirin Kawannon of Kansinji (sculpture) Graceful Kwannon of Hokkiji, Nara (sculpture) Twelve devas in Saidaiji, Nara (painting by Kukai) Riokaimandara of Senjuin in Nara (painting)	
9c	*THE FUJIWARA PERIOD* Japanese books by women The Tale of Genji by Murasaki Shikibu	
Sung (960 to 1280 AD)	Prose by Sei Shonagon Poetry by Akazome Poetry by Komachi	
10c	Use of gold in paintings Grand picture of Amida and the Twenty-Five Angels in Koyashan (painting by Genshin) Amida in Hoodo, Uji, Nara (sculpture by Josho)	Norman Conquest 1st Crusade Romanesque style architecture
12c	*THE KAMAKURA PERIOD* New epoch begun at Kamakura The motto: "To know the sadness of things"	Gothic style architecture

Chinese Dynasty	Japan and the East	The West
12C Sung (960 to 1280 AD)	Zen as the ideal of the Samurai	
	Pictures of purgatory and hell	
	Statues of Monks of the Kegon Sect, Kofukuji, Nara	Oxford University founded
	Great Nioo of Nandaimon, Nara	
Gen/Mongol (1271–1368 AD)	Bronze Buddha of Kamakura	
	Paintings and makimonos (rolls);	
	The Makimono of Bandainagon	
	The Makimono of the Three Battle-Scenes of the Heiji Stories	Osmanli Turks formed
	The Makimonos of Jigokusoshi and Tenjinengi of Kitano	Paintings by Giotto, *It*
14C Ming (1368– 1662 AD)	*THE ASHIKAGA PERIOD*	Printing by movable type invented by Gutenberg, *G*
	The Zen sect of Buddhism as the ideal	
	From the notion of luxury to that of refinement	
	Paintings by Sesshu, Sesson, Jasoku, Noami, Gaiami, Soami, Sotan, Keishoki, Masanobu, Motonobu	Columbus landed at the West Indies
	Birth of No-dances	
15C Manchu (1662– time of publication)	*TOYOTOMI / EARLY TOKUGAWA PERIOD*	Renaissance: Leonardo da Vinci, Michel- angelo
	Gorgeousness and wealth of color in art	
	The Osaka Castle	
	The Momoyama Castle	
	Use of gold-leaf for walls and screens	Dramas by William Shakespeare, Eng.
	Paintings by Kano Yeitoku and his pupils, Tannyu and his brothers	
16C	Architecture:	
	Mausoleums of Nikko and Shiba	

Chinese Dynasty	Japan and the East	The West
16c Manchu (1662– time of publication)	Palace decorations of the Nijo Castle Nishi Honganji Temple, Kyoto Ukiyoe, Popular School paintings; Sanraku, Kohi, Yuwasa Katsushige, Itcho Sotatsu, Korin, Koyetsu, Koho Dainihonshi (The History of Mighty Japan) compiled by Prince Mito	Paintings by Rubens, Rembrandt
18c	*LATER TOKUGAWA PERIOD* Painting schools: The Kano Academies The Tosa School Ukiyoe or the Popular School: Outamaro, Shunman, Kionobu, Harunobu, Kionaga, Toyokuni, Hokusai Articles: the inros, the netsukes, the sword-guards, lacquer-work	
	Democratic art from Kyoto; influenced by later Ming and early Manchu-Shin style and the study of European realistic art	Declaration of Independence French Revolution
19c	Modern Kyoto School of Realism: Maruyama, Goshun, Ganku Painters: Busson (poet/painter), Watanabe-Shiko, Shohaku, Jakuchu	English/French Impressionism in art: Turner, Monet
	Study by Motoori and Harumi of purely ancient Japanese literature The revival of Shintoism American Commodore Perry came	Romanticism in Art and Music

Chinese Dynasty	Japan and the East	The West
19c Manchu (1662– time of publication)	*THE MEIJI PERIOD* The Meiji Restoration The Code of Morality	American Civil War
	Historical paintings by Tameyasu and To-tsugen Yosai Study of Western realistic art Shibakokan, Ayodo	Incandescent electric lamp invented by Edison
	Government Art School at Ueno, Tokyo founded The Nippon Bijutsuin at Yanaka, Tokyo opened	
	Kwannon, the Universal Mother (painting by Kano Hogai) Chokaro (painting by Hashimoto Gaho) Funeral Pyre of Buddha (painting by Kanzan) Kutsugen Wandering on the Barren Hills (painting by Taikan)	
	Mythology Sculpture Ceramics by Kozan Lacquer Work (*The Ideals of the East* published)	

Ch. = China, *Ind.* = India, *Eng.* = England, *It.* = Italy, *G.* = Germany